Barns of Minnesota

Barns of

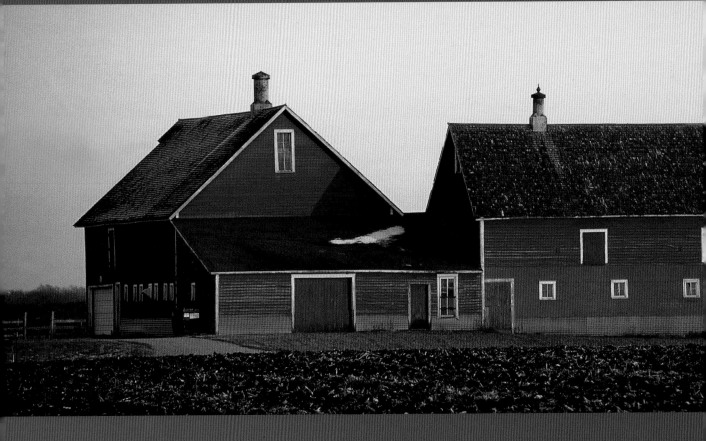

minnesota byways

Minnesota

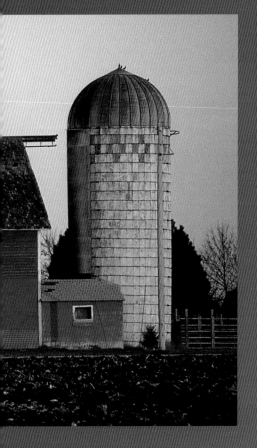

PHOTOGRAPHY BY DOUG OHMAN

STORY BY WILL WEAVER

MINNESOTA HISTORICAL SOCIETY PRESS

minnesota byways

Barns of Minnesota

Churches of Minnesota

Courthouses of Minnesota

Schoolhouses of Minnesota

www.mhspress.org

The Minnesota Historical Society Press
is a member of the Association of American
University Presses.

Manufactured in China by Pettit Network, Inc.,
Afton, Minnesota

Book and jacket design by Cathy Spengler Design

10 9 8 7 6 5 4 3

♾ This book is printed on a coated paper
manufactured on an acid-free base to ensure
a long life.

ISBN 13: 978-0-87351-527-6 (hardcover)
ISBN 10: 0-87351-527-7 (hardcover)

Library of Congress Cataloging-in-Publication Data

Ohman, Doug.
Barns of Minnesota / photographs by Doug Ohman;
story by Will Weaver.
 p. cm. — (Minnesota byways)
ISBN 0-87351-527-7 (hardcover : alk. paper)
 1. Barns—Minnesota—Pictorial works.
 I. Weaver, Will.
 II. Title.
 III. Series.

NA8230.O35 2005
728'.922'09776—dc22

 2004023708

Barns of Minnesota

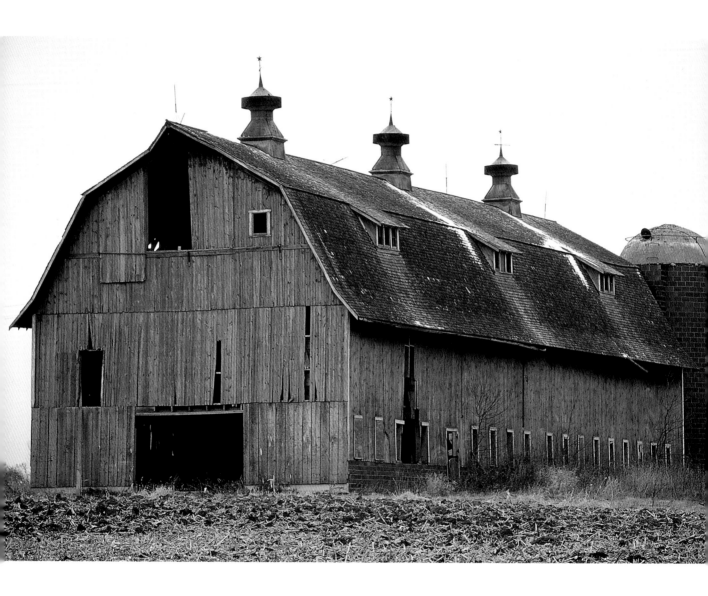

Steele County, 1900, gambrel-roof dairy barn

▣ INTRODUCTION

"The sound woke us up. At first we thought it was far-off thunder, but then we knew."

Friends were talking about their neighbor's barn, the tall, old kind with the wide face and cavernous hayloft. How the big weathered barn leaned more each year—and finally fell. We wondered what, in the end, brought it down. A last sliver of wood gnawed through by a single mouse? The weight of just one more pigeon on the metal cupola? A gust of west wind? For certain, it was a last straw of some kind.

Our old wooden barns—midwestern ones in particular—are falling. The first were built in the 1880s, and few were raised after the 1940s. Like veterans of a great campaign, their work is done, their time has passed. While the occasional tall barn is built in Amish or Mennonite communities, to modern farming technology they are as obsolete as steamships, as coal-fired locomotives.

A few of our old barns remain in use on dairy farms. Some have been restored for hobby farm service. Others have been transformed in more imaginative ways: to music studios, boat storage sheds, country taverns, even apartments. Most, however, sit vacant in the sunlight and rain as we pass by.

This book invites you to pause and take a second look at the big barns of Minnesota. At what meaning, what secrets they might hold. Certainly our old barns have historical value— a direct link back to Thomas Jefferson's and Benjamin Franklin's agrarian vision of America and its "manifest destiny." As well, the architecture and design of barns show the ethnic thrusts (German, English, Dutch, Scandinavian) of settlement into the Midwest. And if you poke around inside an old barn, its doors large and small, its stanchions and gutters, its hayloft and hardware all make for a perfect primer in the history of American farming.

But nowadays one thing is usually missing from old barns: the people. The people who built them, worked in them, depended upon them, left their mark on them in an unending number of ways. Old barns are like gravestones: we admire their design, their strength in the face of wind and rain and time, but we are left to wonder about the people whose lives they represent.

Doug Ohman's photos are of real midwestern barns. My text is the imagined life of one barn. It is a story of what might have been, what could have happened. Together, Doug and I hope that this book gives new voice to our old barns. For if we all pause, look, and listen, they have stories to tell.

WILL WEAVER
Bemidji, Minnesota

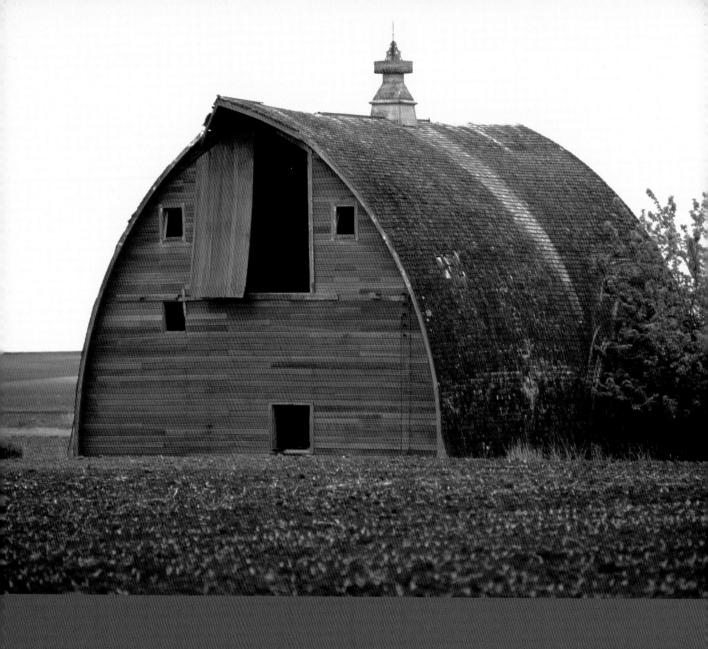

Faribault County, 1930s

1999 ▣ THE FALLEN BARN

In his moonlit farmyard there is a fallen circus elephant.
A beached blue whale. A dinosaur skeleton, its ribs exposed by
a sudden shift in the earth. Emmet Anderson holds aside the bed-
room curtains as he stares out. Lately at night, each time he gets
up to use the bathroom, he looks out. Each time he is surprised.
This is his house, his bedroom—but how can this be his yard?
Where is the tall, round-faced dairy barn? ▣ And his wife, Clara,
where is she? She was not in bed—there is no warm spot where
she lays. And Ralph, the hired man? It's almost five o'clock in the
morning; he should be crossing the yard any minute now, a small,
stooped figure heading to the barn to turn on the lights. Lit at
night, his barn always looked like an ocean liner. The row of small,
square windows along the side, the pointed nose, the round cupola
like a smokestack on a great steamship. But tonight the sea is

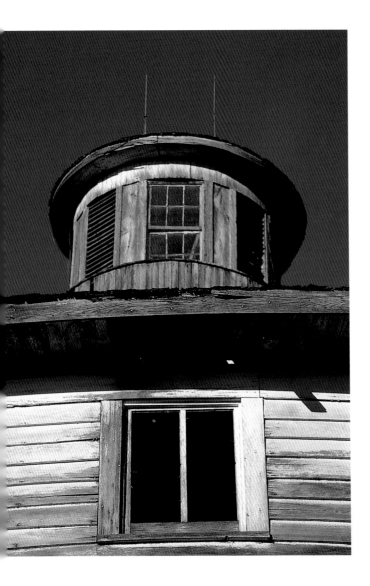

empty. Empty but for some colossal wreck washed ashore while he was sleeping.

Emmet does recognize his long chicken coop with its row of south-facing panes. He knows his silo; his slatted, drive-through corn crib; the well house; the garage; and machine shed. Beyond the windbreak, the old threshing machine, frozen with rust, stands watch like the last buffalo. But the moonlight in the yard is wrong. The moonlight is too full. Moonlight as full as a Surge kettle milker brimming over. Moonlight as full as a separator bowl spun high with cream, frothing up and dripping down the sides where, on the floor, the mewing barn cats will spit and fight for first lick. And where are they? Orange Beezer who slept winters on a Holstein's back, and furry Leo, the wary one but the best mouser in the hayloft. Where have they all gone?

Then he remembers. It is almost a new century. He is very old, either ninety-five or ninety-six—what does it matter? Clara has been dead for twelve years, Ralph nearly six years, and his barn has been down since that bad windstorm in May. He lets out a long breath and feels his heart turn over with grief. At this moment, as every night, he lets the curtain fall back; returns to bed and tries to sleep.

ABOVE Renville County, 1910s, cupola from an abandoned round barn

RIGHT Big Stone County, 1910s, abandoned gable barn with add-on horse barn

But not tonight.

Tonight feels different. There is that bursting moon and some new fullness in chest on this humid summer night. Fireflies burn and blink their tiny green lanterns, crickets cheep and call, a saw-whet owl murmurs "too-too" from the machine shed, a white moth flutters, mosquitoes gather to his breath with their fine needling whine just outside the window screen. Suddenly a slash of falling star—arcing down from the west, disappearing into the black hulk of his barn.

His fallen barn.

Like a wheel turning, his mind loops back through time and he sees the life of the barn, which is really his own life. The life of his family,

too. Suddenly he blinks and looks again. Something is moving among the wreckage of barn.

He squints and rubs his eyes. It is probably only the flutter of some night bird among the broken rafters, the splintered boards—but there it is again. He is certain that something moved. Again—there—the broken back of the barn twitching. Shifting every so slightly side-to-side. Like a downer cow trying to find its feet, like an old elephant on his knees, Emmet's barn hunches forward, then back, a rocking motion. His barn groans, cracks, strains, heaves. He says something out loud—clutches his chest—as the barn's gable ends tilt outward, its spine stiffens, its sidewalls straighten. The old barn is rising. ▣

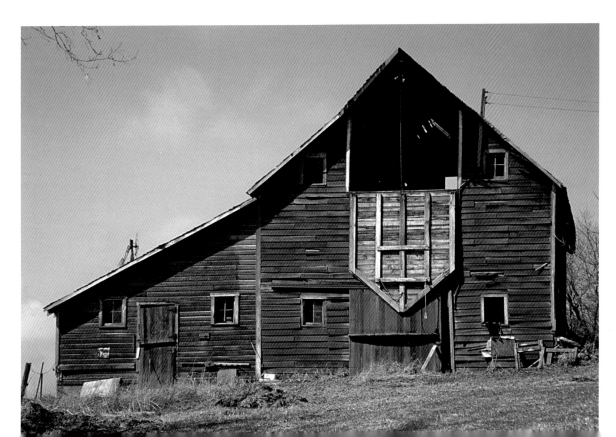

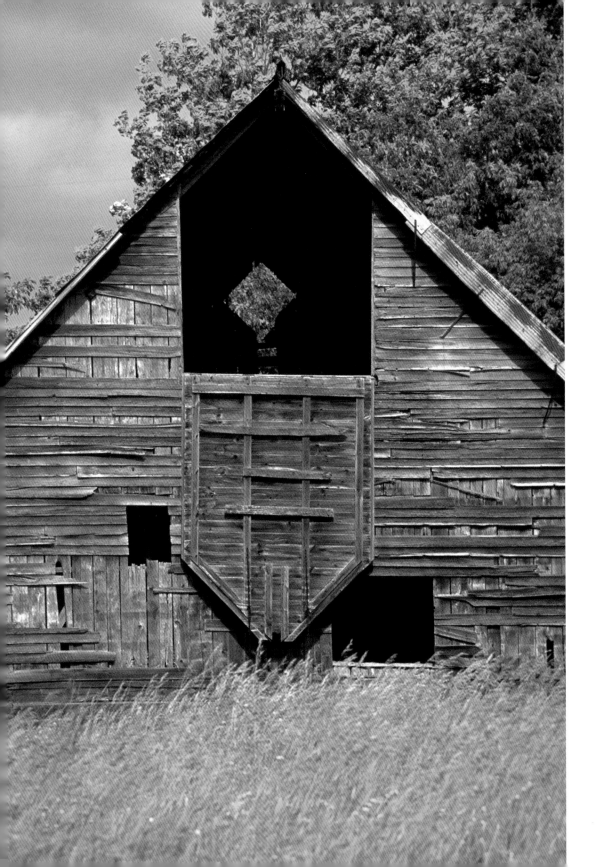

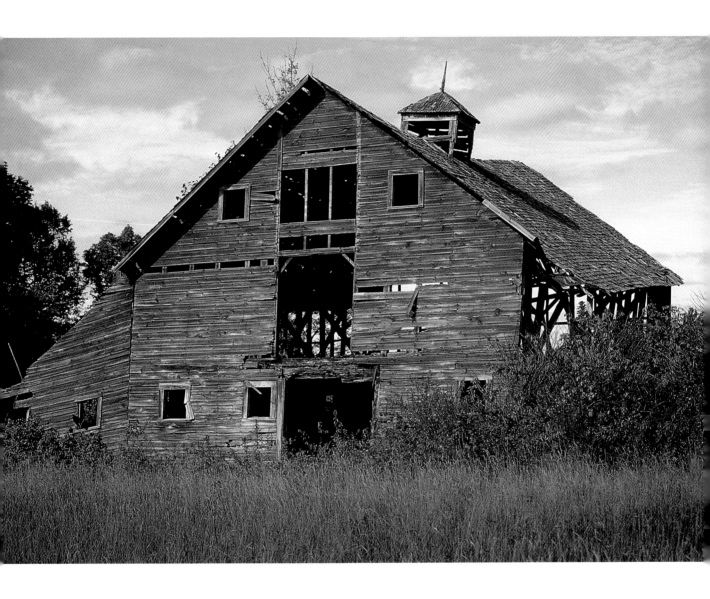

LEFT Pine County, 1900. The barn has been layered with both vertical and horizontal siding.

ABOVE Crow Wing County, 1900, dairy barn

NEXT PAGES Kanabec County, 1930s

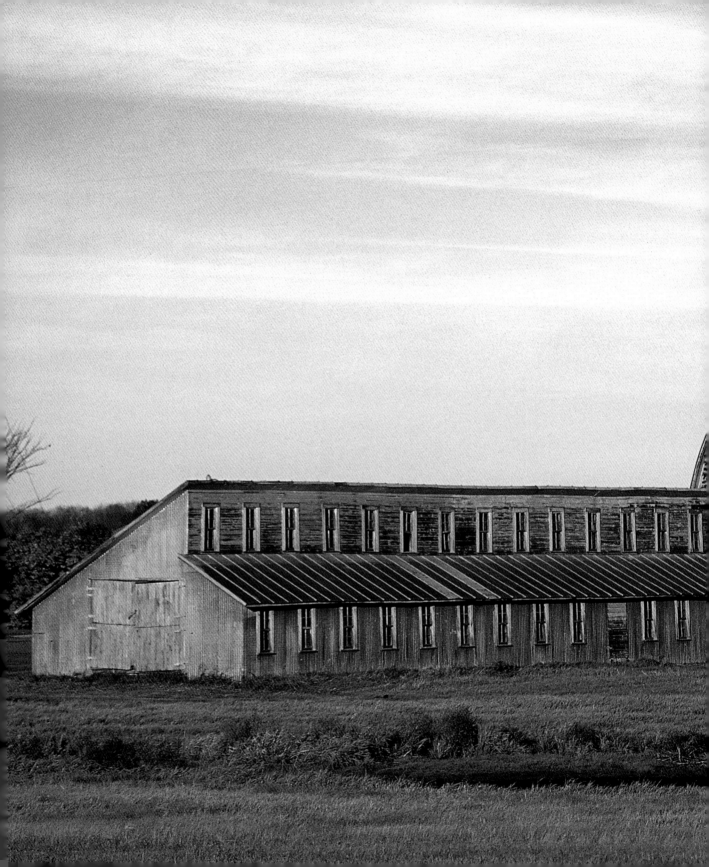

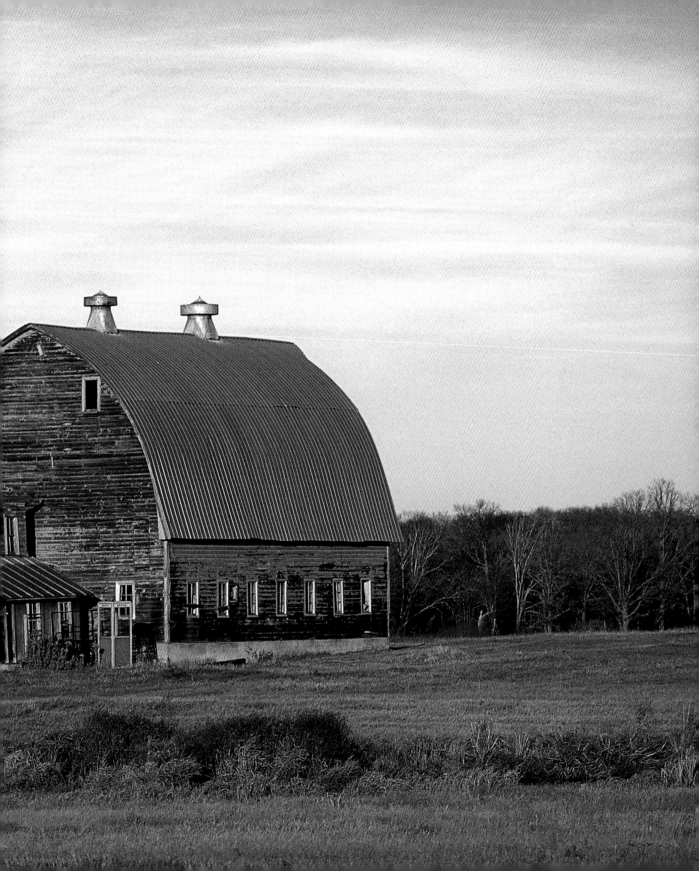

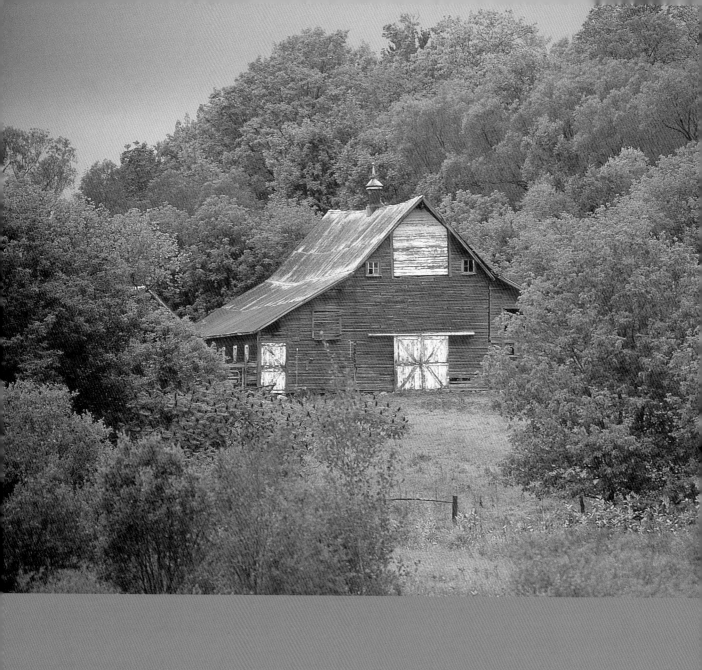

Aitkin County, 1920s, small multiuse barn in north-central Minnesota

1924 ◉ BARN DREAMS

Emmet and Clara Anderson arrive in north-central
Minnesota on the train. They have brought from Iowa ten Duroc
sows, some cast-off farm implements, a few household things, and
their two small children, Joseph, two, and Emma, a baby. Land is
still available and cheap this far north in lake country, the south-
ern edge of the cutover region. The soil is sandy loam, nothing
like the heavy dark Iowa earth of Clara's father's farm, but here
at least they will have their own place. On this they have agreed.
◉ The quarter section Emmet has bought includes sixty acres of
open land with another eighty or so of cutover brush, plus twenty
of timber. At sight of the farmstead and its dumpy log buildings,
Clara cries and turns away. The house is an old log cabin, really;
Emmet had described it in somewhat nicer terms. ◉ "How can
we ever . . . ?" Clara begins, but her voice breaks.

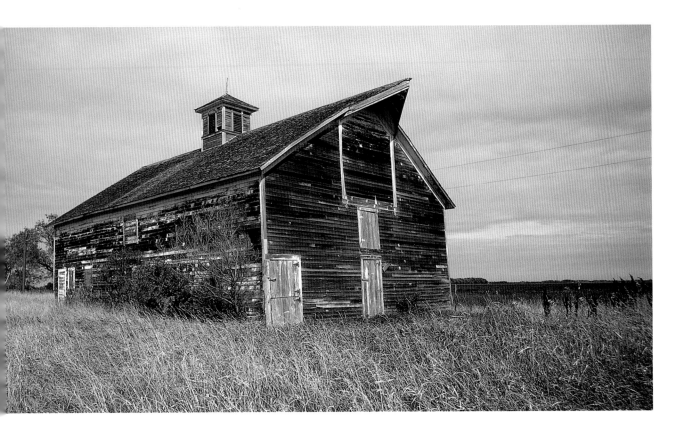

"Well, the house is sturdy. It doesn't leak. It will be warm in winter—there's plenty of wood to burn and build with—and the outbuildings are perfect for the hogs."

She will not look at him.

"I figure we can get by for a couple of years until we build the dairy barn and a new house," Emmet says. He is not a naturally affectionate man, but he puts both arms around her. He figures that if ever there is a time for such things, it is now. He holds her close, looking over her head, her auburn hair, at the land—their land—and is

ABOVE Marshall County, 1900, the last remaining sign of a once large and prosperous Red River Valley farm

filled with an overwhelming desire. A desire to work. He wants to begin right now: cutting, clearing, fencing, plowing, building.

Emmet has dimensions for a new barn in his head and on his own well-worn, meticulous drawings that he brought from Iowa. This will be a tall, dairy barn, like those in southern Minnesota they saw from the train. A double row of Holstein cows. A common alley down the middle. Calf pens at the end. Haymow doors—not just one at the far end—so the loose hay can be forked straight down in the mangers. Better ventilation than the barns he'd worked in, including a cupola in the loft to suck away moisture from the fresh hay. In Iowa he had "worked out" for other farmers besides his father-in-law—a way to save his money, to save for his own barn. His barn is all he thinks about, reads about. He bought new the book *Barn Plans and Outbuildings,* but found it too old (1889 printing) and mostly about New England. He has the latest Sears catalogue with its "Honor Bilt" barns that he could buy by the foot and have delivered on the train that runs only a half-mile north of the farm. But Emmet wants to build his own barn from his own plan, and by the second spring has enough of his pine timber cut, milled, and dried.

"I thought we would build the house first," Clara blurts out. Round with their third child, a summer birth, she has been silent for days. "You said a couple of years. That's what you said—a couple of years." And suddenly she cries with abandon.

Emmet is caught off guard. He cannot understand this. He has a plan: his hogs pay the bills—he has sixty of them now—and pork prices are up. It's all working. But now this, with Clara.

"A barn will build a house sooner than a house will build a barn," he says. He should go to her, take her in his arms again but does not. He fears he will weaken and put off building the barn.

"Back home at least we lived in a decent house," Clara says.

"We will soon," Emmet says. "I promise. But first the barn." ◙

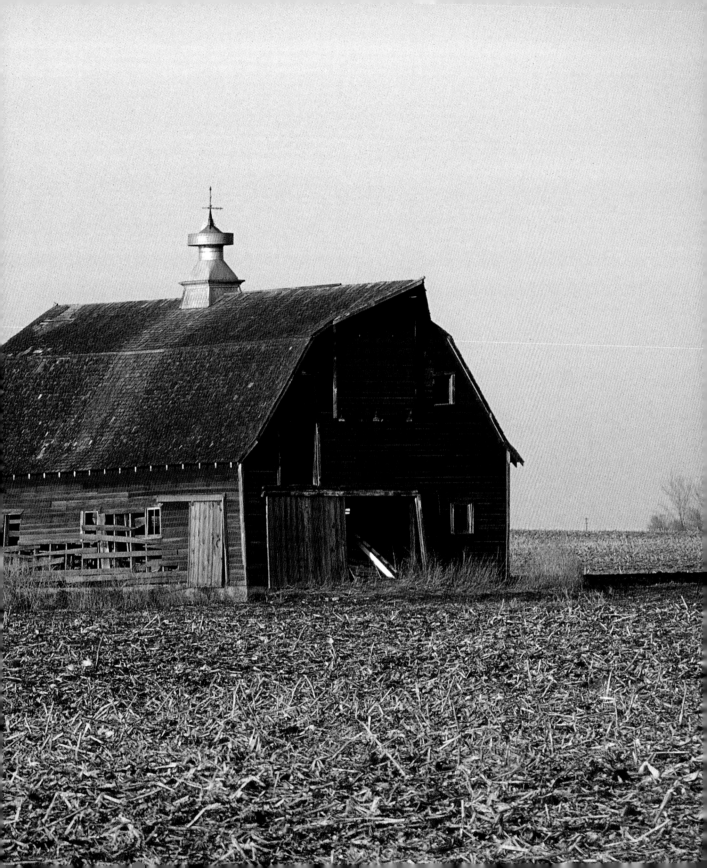

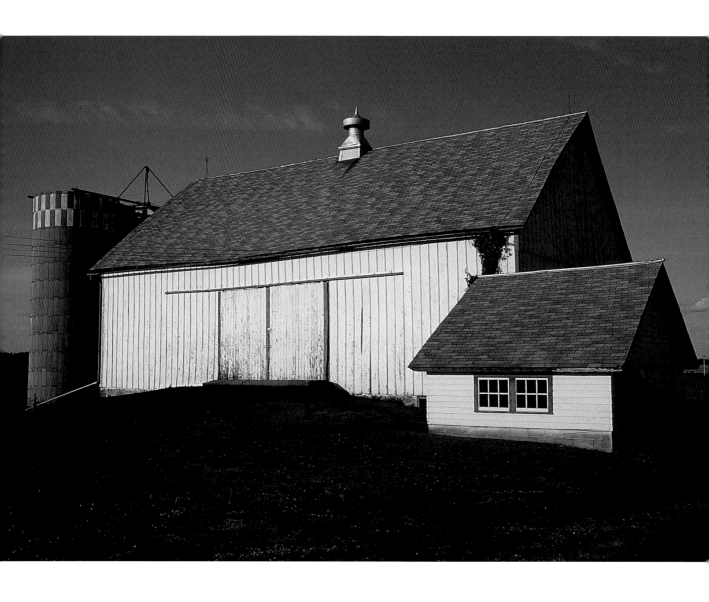

PREVIOUS PAGES Lac Qui Parle County, 1920s

ABOVE Hennepin County, 1890s, bank barn with matching milk house

RIGHT Wright County, 1870s, three-bay threshing barn sometimes called a "Yankee Barn"

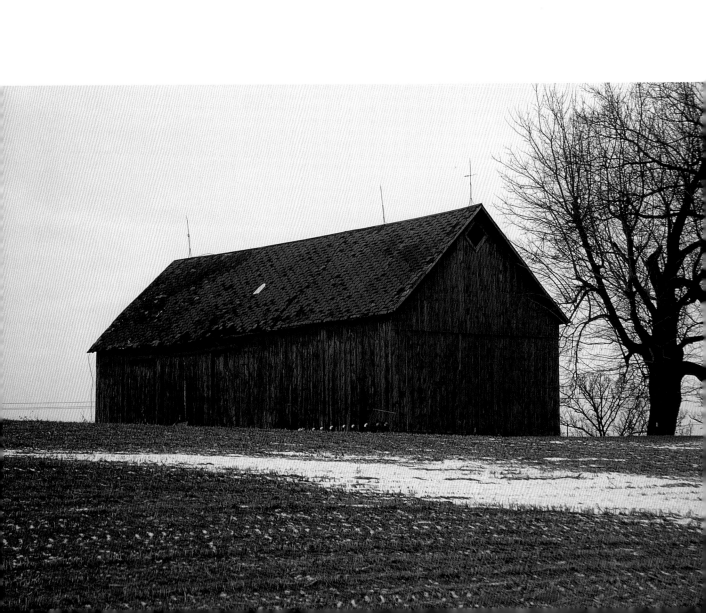

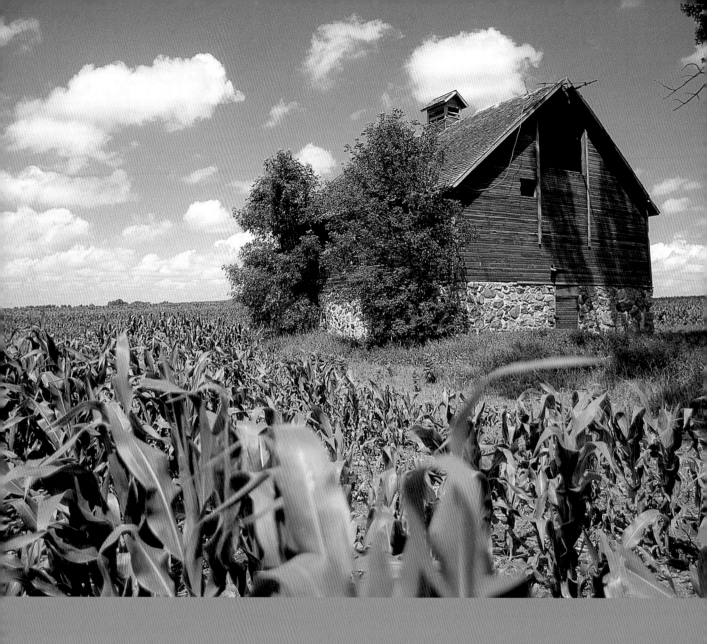

Stearns County, 1880s, German barn with a foundation built of local granite fieldstone

1926 ◙ THE FOUNDATION

To help with the footings, Emmet hires a small crew: Hans Deukman, a short but barrel-chested German fellow and Emmet's closest neighbor, and two of the slender Whitcomb boys, Conrad and Henry, from down the road. They arrive on Monday a full hour later than promised, but bring Deukman's big Percheron and a dragline. Deukman runs a sharp-edged bucket, about three feet wide, like a walk-behind plow as he and Teufel (the Percheron) dig long, narrow trenches a few inches at a skim. The Whitcomb boys lean on shovels as they watch the big horse pull while Deukman wrestles the dragline bucket. They are boys with bowl haircuts and slack jaws, boys for whom the world is continually a new challenge. ◙ But soon it is time to square the trenches with hand shovels, and Emmet gets his money's worth from the lads. The trenches are dug waist-deep and then some; Emmet has seen how

far the frost sinks here in Minnesota. His son Joseph, a lively, curious boy with reddish hair like his mother, loves to run along the trenches—they are cool and sometimes house colored, spotted salamanders—but Emmet forbids him to play in the digging. So Joseph, now four, climbs high on to the lumber pile or still higher up a tree so he can watch. He is a quick, fearless boy and Emmet must keep an eye on him at all times. Ordinarily it would be Clara's job, but she is heavy with child and does not talk much these days. She does not seem ill, just silent most of the time.

Her condition weighs on Emmet, makes him work all the harder. But he does not hurry. Rushing leads to mistakes, to shortcuts from his precise drawings. Today, as he uses a level one more time to check the wooden footings that will take the first concrete, Deukman noisily snaps open his pocket watch. *Es ist nicht eine Kirche,"* he mutters to Teufel. Teufel stamps one heavy hoof.

"No, it's a barn, but things have to be level," Emmet says, "especially the foundations."

By the end of June the concrete and fieldstone knee walls are completed. Emmet has plenty of rocks, picked by hand from his fields as well as stones turned up in the trenching, and puts them to good use. "The more rocks we use, the less

concrete to mix," he says. This appeals to Conrad and Henry. Resting on flat concrete footings, rising twenty-four inches above grade, the knee walls are important. Over winter, livestock pens can build up with a potent combination of dung and urine, which eventually rots regular board walls. Emmet has seen this in other barns when he worked out. He will not make that mistake in his barn.

Atop the knee wall is a picket of black bolts, heads down and frozen in the concrete, their threaded ends poking upright. The bolts will anchor the sill plate, the first layer of wood in the new barn.

"We got to measure where all those holes will be?" Conrad Whitcomb asks. The youngest of the boys, he is easily discouraged; Henry is not much better.

"No, there's an easy way," Emmet says. The brothers perk up at the word "easy."

With Emmet guiding, they lower a long, rough-sawn 2 x 8 atop the sill plate bolts.

"Now go along and tap it hard with your hammer," Emmet instructs.

Conrad and Henry are puzzled but obey; Hans Deukman pretends to understand, but doesn't.

"Lift up the sill plate and turn it over," Emmet says.

Washington County, 1892, pegged mortise-and-tenon construction

They do. When the Whitcomb brothers see the dents—perfect pilot holes—in the soft pine, they grin like fools. "Now all you have to do is drill the holes," Emmet says. Their faces fall like thrown horseshoes as he hands Conrad a hand auger and Henry a brace and bit. They set to work, and sweet-smelling shavings of pine curl from the holes and the bits punch through. Soon the sill plate is set in place.

"It fits!" Henry exclaims.

Emmet only smiles.

A circular washer and a nut go onto each bolt. The boys go down the line with ¾-inch box-end wrenches. Emmet follows with his own to make sure that each nut is just right—tight but not too tight.

And so the barn rises.

But slowly. The pace is worrisome. Clara is growing faster than his barn. Emmet's is not a timber-framed barn, common in Iowa and southern Minnesota. Emmet's is not timber-framed because he does not have oak or black walnut beams that farmers farther south can cut from their own land. Yes, he has Norway pines, but their softness worries him, and he decided that they were best sawn into planks and boards. Which leads to the second reason. With planning (much

of the nailing and pegging is done on the ground) and a large crew, a timber-framed barn can be raised in a day. Emmet is new in this township. Farms are few and far between and there are not enough neighbors, he is sure, for a barn raising. Besides, with small boards and planks he can do more of the work himself and thereby make sure things are done correctly.

His will be a "stick-built" barn. A six-foot-tall stud wall, hammered together on the ground, is

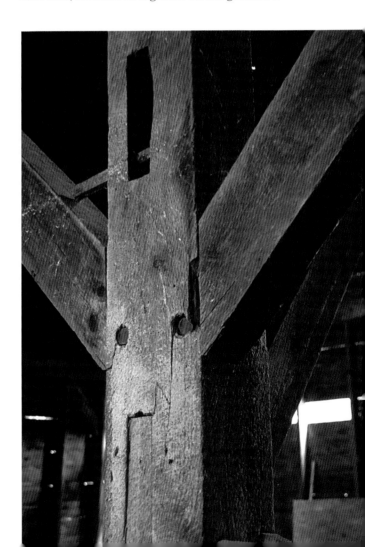

tilted upright atop the plate and nailed with heavy spikes. With the two feet of knee wall, this will yield an eight-foot ceiling inside the barn. "Eight feet!" Deukman exclaims. "You waste the wood. Six feet, or six and a half is plenty."

"Maybe for you," Emmet says easily, and the Whitcomb boys laugh.

In a grid pattern inside the 34 x 60-foot rectangle, Emmet digs round holes with a posthole digger. The holes are for the upright head tree posts, on top of whose bolsters will rest the main girders. The heavy girders run lengthwise down the barn. Floor joists, 2 x 12 rough-cut and 16

inches on center (Hans argued for 24 inches on center), will run the opposite direction, side to side, and rest on the main beams. On them will be nailed the floorboards of the haymow, and atop that, the rafters for the tall loft.

But first things first.

One thing at a time.

Emmet measures exactly where the posts should be (each will rest on its own concrete footing). Before planting the uprights, Emmet has the crew soak the post ends in kerosene and drain oil (Deukman mutters something in German about this) and afterwards, makes sure the boys tamp the posts tightly and exactly vertical. He uses a four-foot level to check each one.

That night, as he looks out in the moonlight, the barn is like a page from his old high school history book. Like a picture from ancient Greece or Rome—one of those old buildings where only the stone columns remain, and one must imagine what rose above them. Emmet can hardly wait for sunup when he can get back to work laying the girders, the floor joists.

By mid-July, working mornings before the heat rises, they are ready for the haymow floor. Clara comes out always at noon with dinner for the men, but she moves slower and more ponder-

ously these days. The sight of her makes Emmet eat quicker so he can get back to work; however, he always give his crew a half-hour (though not a minute more).

The haymow floorboards are planed on one side, plus tongue-and-grooved so the floor will be smooth and tight. Hay will slide easily to the open mow doors, and no chaff will filter through the boards onto the backs of cows and into the milk pails. It is another detail that he noted years ago in careful handwriting on his drawings.

Then, on August 1, works stops. Clara goes into labor with their third child. It is not an easy birth. The new baby girl, Dorothy, almost doesn't survive. She is jaundiced, and Emmet himself holds her for an hour every morning in full sunlight on the south side of the barn. The sun collects there in the un-painted wood and the stone knee wall. Gradually her color improves and her cries are stronger. Clara remains mostly bed-bound, and Emmet must take Joseph with him into the fields even when he scythes hay, a worrisome business for the boy to be anywhere near the long, sharp blade.

And the half-barn sits there. Twice it rains on the partially completed haymow floor, and some of the boards cup moisture. Hans Deukman is haying on his place, and Conrad and Henry come every other day to work on the haymow floor (anyone can nail down tongue-and-groove boards), but they are agonizingly slow. The floor advances only a yard or so a day. At this rate Emmet will not have the rafters up before the snow flies.

Then, one day in mid-August, when he is stacking the last of the loose hay in his meadow, Joseph calls out suddenly. "Poppa—look at all the people!"

Emmet turns. He sees a dusty caravan of horses, wagons, and Model T trucks. Twenty or so men and many of their wives and bigger children are coming up the long driveway. He thinks some-thing terrible has happened—another war has broken out, a plague of smallpox, something very bad. He gathers up Joseph and holds him tightly as they hurry to see what's the trouble.

A fellow from the feed mill, Bill Johnson, is leading the way. He is a farmer with whom Emmet has had a couple of conversations at the feed mill, but no more than that. Some of the other men Emmet knows only by face from the mill or the sale barn where livestock are bought and sold; several families are strangers to him. They gather around him in a half-circle, with peculiar smiles on their faces. "Well, Emmet," Bill Johnson says. "We come to raise your barn." ◙

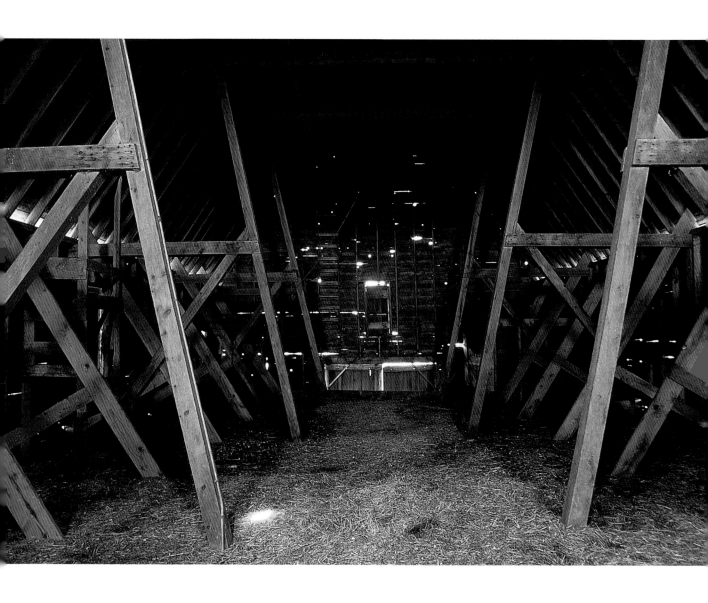

ABOVE Rice County, 1900s, empty haymow in a large gambrel-roof barn

RIGHT Scott County, 1913, haymow of a round barn

NEXT PAGES Winona County, 1880s, German bank barn. Note the extended forebay.

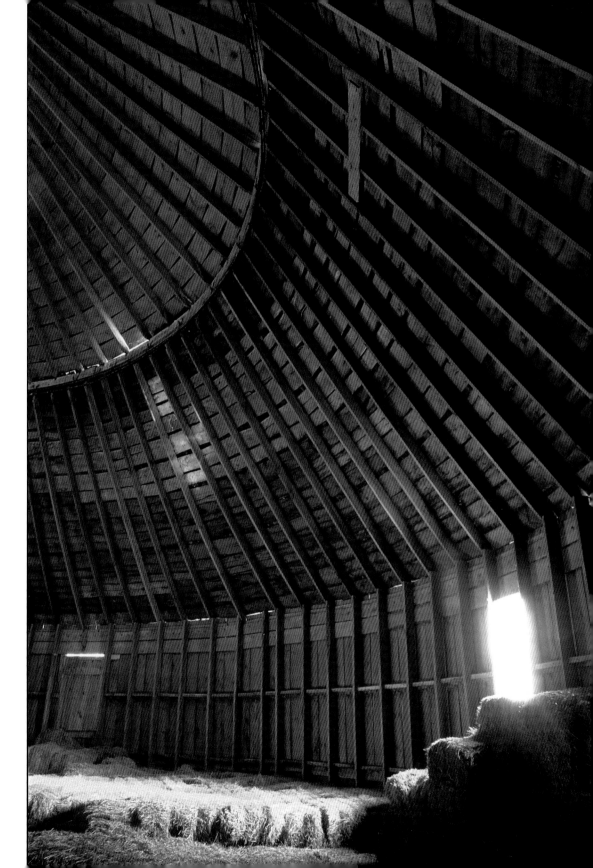

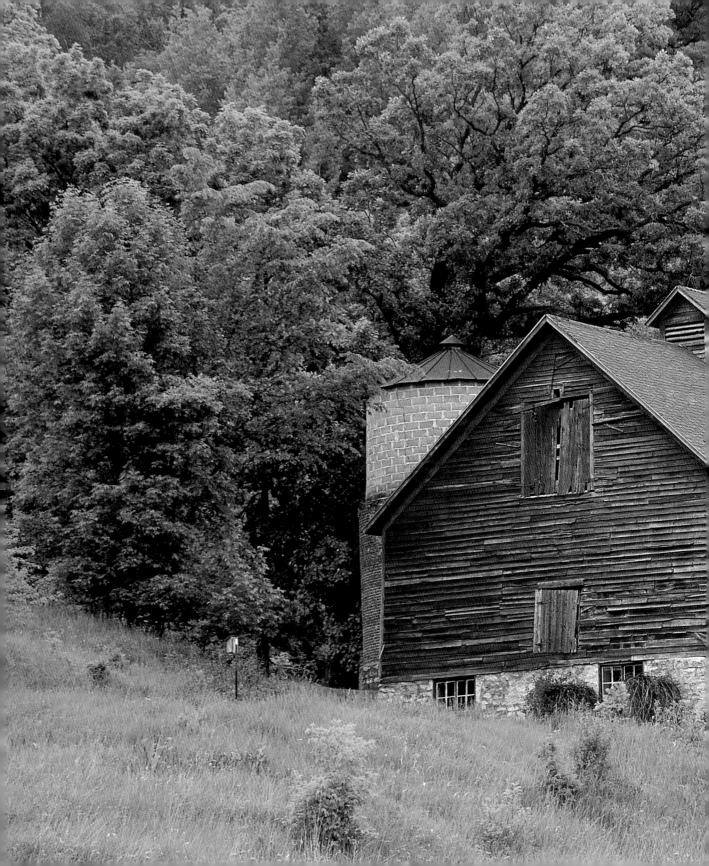

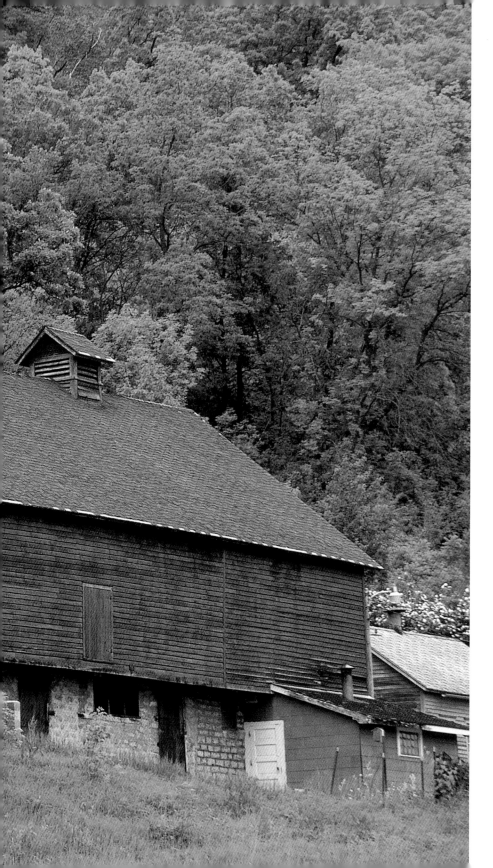

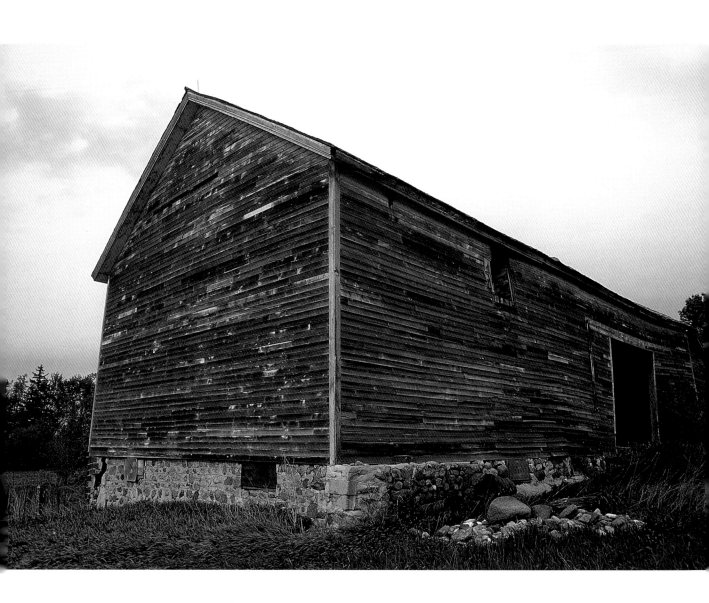

LEFT Faribault County, 1890s. Note the fieldstone foundation of this abandoned barn.

BELOW Rice County, 1925. The "Sugardale Barn" can be seen off Interstate-35 south of the Twin Cities.

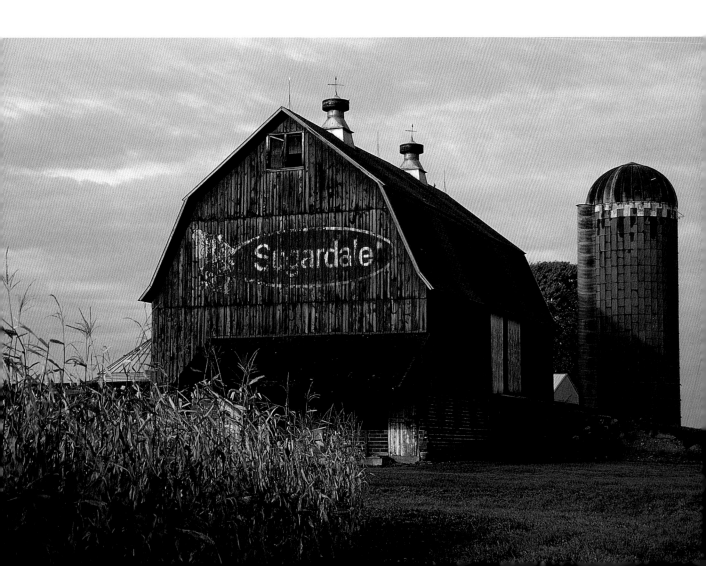

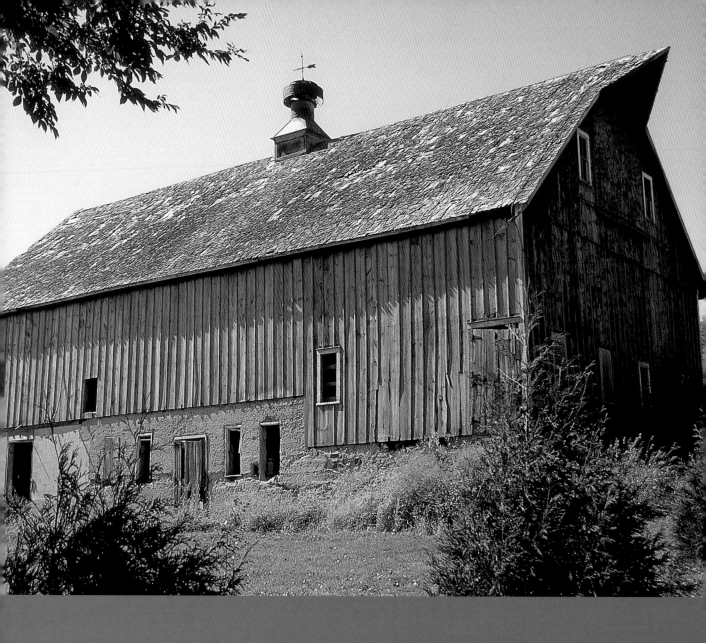

Waseca County, 1910

1926 ◙ THE BARN RAISING

Looking out now in the moonlight on the fallen barn, Emmet

remembers that day, that hour like a movie complete with color

and sound. The good-natured laughter at Emmet's surprise.

The gloomy face of Deukman, begrudging volunteer. The loud,

blustery, dark-haired Alphonse LeVeq, a Frenchman from the

north end of the township; he was there with his wife and her

slow, older brother, Ralph. The women went immediately to

the house and set to work cleaning, sewing, and "freshening."

◙ Bill Johnson took charge of the barn raising. "You men get

started on the haymow floor. Tongue-and-groove, keep it tight.

You boys—bring around those sawhorses and planks, and make

tables to eat on." Soon hammers began to ratta-tat and handsaws

rasp; Emmet tries to be everywhere at once, but cannot. He has

a sudden dizzying feeling. All his careful planning and work is lost: his barn will be crooked and ruined at the very end.

"Square and tight," Bill Johnson calls to the men on their knees in a line along the haymow floor. "Make sure those nail heads are countersunk out of sight." And the mow floor begins to fill the length of the barn like a tide coming in, slow but steady. In less than two hours the floor is nearly finished, though first the dinner bell rings.

The women have brought along white sheets for tablecloths, and there was a picnic dinner for more than twenty. He remembers the food: chicken and dumplings, cucumbers and garden dill in vinegar, sauerkraut in Red Wing crocks, fresh bread and rolls, apple pie. He remembers the scent of the food, the clink of the silverware in the yard.

"I figure we can get the rafters built this afternoon and up tomorrow," Bill says.

"I don't know about that," Emmet says dubiously.

Deukman, sitting by Al LeVeq, mutters something. "Emmet thinks he's building a church," Al says as if it were his own joke; all laugh largely. In this moment of opportunity, when the others are occupied, Al's brother-in-law Ralph reaches

for another chicken leg. Like a snake striking, Al whacks his hand. "What do you think you're doing? I'll tell you when you can have another chicken leg."

Ralph jerks back his hand, pulls in his neck like a turtle, like a dog expecting another blow. The eaters around the table go silent.

"You'd think we didn't feed him," Al says with a guffaw.

A couple of people chuckle politely.

"Well, there's plenty of food," Bill Johnson's wife says evenly. "Someone pass Ralph the sauerkraut."

Ralph gives Al a beady, sideways glare of triumph and heaps up his plate.

All of this seventy-five years ago, but the movie runs bright and clear in Emmet's head. He remembers the hum of passing bumblebees, the stomp and thump of horses against the horseflies of late summer, the shouts of children as they raced off to play.

While the men returned to finish the mow floor, Emmet and Bill consulted over the barn drawings. Emmet was worried that Bill might mock the formality and detail of his drawings, at his long list of tiny notes and observations. Bill said only, "When we're all done, you should keep

Scott County. Built in 1913, this round barn continues to be used by the original family in a small dairy operation south of the Twin Cities.

these in a safe place. Some day your kids might want to have them."

And then they talked rafters. The plan was for a jig to be laid out on the haymow floor, then 1 x 6 boards curved around the jig and nailed in overlapping patterns.

"We'll have to watch the seams," Emmet said of the rafter boards, "if we have more than one butt-joint, there goes our strength."

"I've built many a curved rafter," Bill said evenly.

"And we have to use plenty of nails—and clinch them, too," Emmet says.

"Emmet, let him do his work," Clara said from her chair.

The two men look up, surprised; the other women turn as well.

"If you can't trust your neighbors, who can you trust?" Clara adds.

"Thank you, ma'am," Bill says with a smile. He turns to Emmet. "Tell you what. I'll make you the manager. All you got to do is walk around and make sure things look good."

"Emmet, walking around and not actually working?" Clara says. She actually smiles; Emmet has almost forgotten what her smile looks like.

"I don't want you to even pick up a hammer," Bill says.

"All right," Emmet says, "but I'll be carrying my rule and carpenter's square."

He remembers, three-quarters of a century later, Bill's quiet laughter, the intense fellowship—a kind of love, even—in that moment on that summer afternoon. And how, not a minute later, the

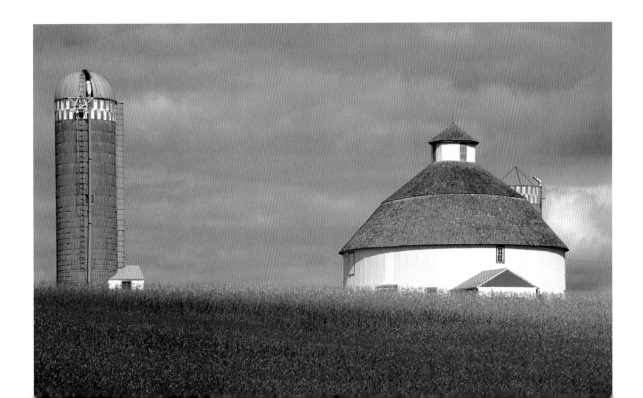

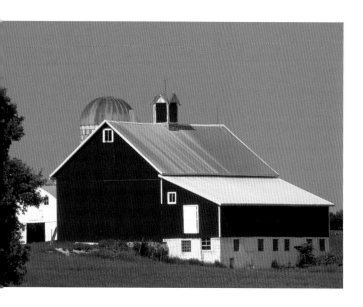

draws a perfect line, along which the jig blocks are nailed down. Like a bucket brigade but with boards, men and boys are staging a pile of long, rough-cut 1 x 6 boards on the opposite end of the haymow floor.

Emmet and Bill lay down the first 1 x 6 board on edge, and bend it a few degrees to fit the jig. Another board is laid down beside it, though off-set by half, and so on. Each board is nailed to the other, the nails clinched, and the rafter grows to six inches thick. It curves across the floor like the first bones of a rib cage. "Next," calls Bill Johnson, as the men loosen the jig to free the first rafter.

"Assembly line. Just like old Henry Ford did it," Bill says as work continues.

Emmet supervises the placement and temporary bracing of the first rafter. When it stands erect he hears a bright voice from the yard. It is Joseph.

"Poppa! It looks like a giant," he shouts.

By late afternoon, when the men must return to their farms for chores, half the rafters are in place.

"Tomorrow—first thing in the morning!" Bill calls to the men. There is good-natured grumbling and the group departs. Emmet is suddenly exhausted—not from work, for he has hardly

hammering sounds suddenly died behind them. When he and Bill Johnson turned to look, men were standing upright and walking the full length of his haymow floor as if it had always been there.

A jig is a form, a template set down, in this case on the haymow floor. The floor has been swept clean by two younger lads, including Bill Johnson's son, who watch the men lay out the rafters' measurements. Bill and Emmet work with a carpenter's pencil, a folding "rule," and a long piece of string. There is geometry here, arcs and degrees. Tied to the end of the string, the pencil

swung a hammer—but by so much talking. So much activity. So much life around him all day. Shoulders slumped, he heads to the cabin where it's quiet and cooler. Clara is nursing the baby.

"So. You have your barn," she says in the dusky light. Her teeth show white.

"Almost," Emmet says. Joseph and Emma, spent from play, sleep beside her, and Emmet, too, lies on the plank floor and rests. On most days he could take a short nap, but on this day he can only look at his family and feel blessed.

The weather holds, and by the third day the rafters and ridge pole are secure, the roof boards nearly complete. The younger boys take pleasure in the latter, a simple task with quick results to the eye. They start at the bottom of the rafters and work their way, course by course, toward the ridge-line. Bill and Emmet make sure they keep the line of boards parallel and square and that they use safety ropes as they near the top. The fall to the ground would be nearly forty feet. By later afternoon they reach the summit. Emmet himself climbs up to cut the hole for the cupola. He straddles the ridge, sitting as if on a horse, for a slight wind has surprising strength this high. Before setting to work, he looks out across the farm.

His farm. He can see all his fields, and the tree line beyond, the railroad tracks like two silk threads stretching west. He feels a great, deep peace take hold of him—until he hears a voice.

"Poppa, I came up too." He swivels so fast he must brace himself. It is Joseph, coming along the ridgeline, walking as if it is no more than a board on the lumber pile.

"Joseph!" Emmet says. There is something in his voice that stops his son in midstride.

"What, Poppa?" A gust of wind tilts the skinny boy slightly, and he bends his knees and holds out his arms for balance. As if he were flying, Emmet

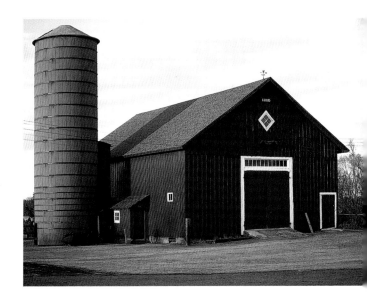

LEFT Meeker County, 1880s, well-maintained nineteenth-century grain barn now being used as a dairy barn

ABOVE Sherburne County. This English barn with board-and-batten construction was built in 1880 by the Cater family to support their 8,000-acre wheat farm.

would remember later, as if he were ready to take off like a bird. Emmet's mouth fills with bile of fear.

"Joseph! Sit down, right there," Emmet says. "Don't move."

On the ground Clara cries out with alarm and Joseph looks down.

"Hi, Momma! Look at me!" he calls. He waves. Emmet scoots forward, sliding closer. While Joseph waves to everyone, Emmet covers several feet, close enough to lunge and grab the boy.

Joseph laughs with delight. "Poppa, it's fun up here!" he says. He is looking over Emmet's shoulder at the horizon, at the people below. "Look how far you can see!"

"Never climb up here again!" Emmet says.

"But Poppa, you came up here."

"It's too high for little boys," Emmet says, and squeezes him tighter as he takes hold of the safety rope. Bill has hurried up behind him, and the two men escort Joseph to the ground. Clara is waiting, her eyes teary but she's also holding a fly swatter.

"You come with me, young man," she says, grabbing his wrist and giving him a single whack on his butt.

Joseph begins to wail as if grievously injured as he is hustled back to the house.

"That boy has no fear of heights, that's for sure," Bill says.

Emmet's knees suddenly feel shaky.

"Why don't you sit down a spell," Bill says. "I'll finish that cupola hole. Me and the boys can hoist it up there. I'll tar it and bolt it down myself."

Emmet surprises himself by nodding in agreement. He watches, from below, while the bright metal cupola is winched upward, then erected in place. It is like the steeple on a church, and as the men step away, its little weather vane swings to the west.

When he arrives back on the ground, Bill says to Emmet, "I know some good shinglers." His meaning is clear. Shingling is too much to ask of the neighbors—they have already given three full days—and it's too dangerous besides.

"There's a crew from up on the reservation. They've got a shingle splitter, the works," Bill said.

"Indians?" Emmet says.

"Yes," Bill says. "They got all those white cedar swamps up there, and that's how some of them make a living."

"Indians," Emmet says, "I don't know. . . ."

"I'll vouch for them," Bill says.

Emmet looks at the endless arch of pale, Norway pine boards. It seems impossible that he had

Waseca County, 1930s, metal barn ventilator with simple decorative stamping and glass-ball lightning rod

planned to shingle the barn by himself. The dry weather will not hold forever. He nods. "All right, I'll give them a try."

They come the next week, three Indian men, one who stays on the ground and keeps things organized and two who scramble up the ladders without holding on, a square of shingles on each shoulder.

They are quiet, polite men who smell different in not a bad way, like wood smoke and tallow. Joseph takes a great liking to them and tries to climb onto the roof with them, of course. On their lunch break, the men use long, sharp pocket knives to make him an eagle from thin scraps of cedar. The cedar is shaved so thin that daylight shows through the bird's wings. Joseph is delighted and pitches his toy into the air again and again. When it breaks, they patiently fix it. When it breaks again, they show Joseph how to use a knife, how to carve a bird of his own. Emmet holds his breath, but says nothing. He is surprised at how careful Joseph is with the knife.

By the time the shinglers are done Emmet is ashamed of himself. It would have taken him a full month to shingle his barn, and he has never seen men climb so easily and work so quickly. It takes the crew five days, but he pays them for six.

He wants to say something to them, blurt something like, "I never got to know an Indian man before this." But he doesn't. The men and Emmet have gone beyond that already, into a space where nothing needs to be said. They give soft, shy handshakes in return and are gone on Friday.

Joseph cries when they leave. Forever afterward he calls them "the birdmen." ◙

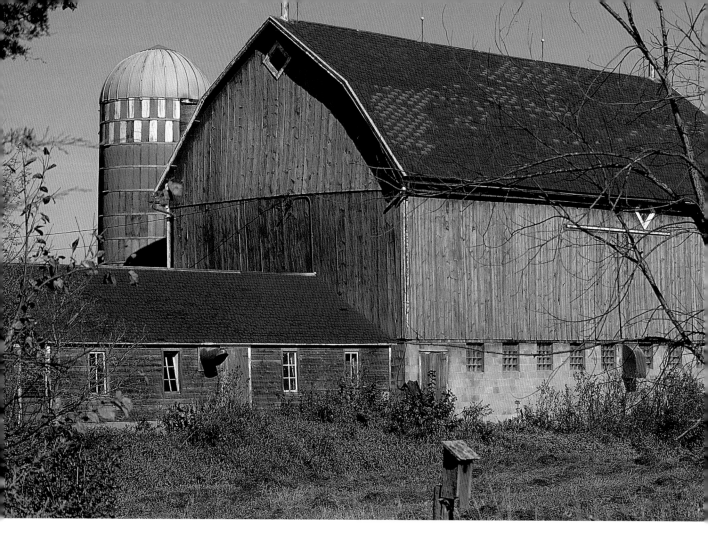

ABOVE Hennepin County, 1915, dairy barn with an add-on poultry barn

RIGHT Hennepin County, 1920s. Known locally as the "Ghostly Farm," this is the only round barn left in Hennepin County.

NEXT PAGES Waseca County, 1880s, gable shed-roof barn

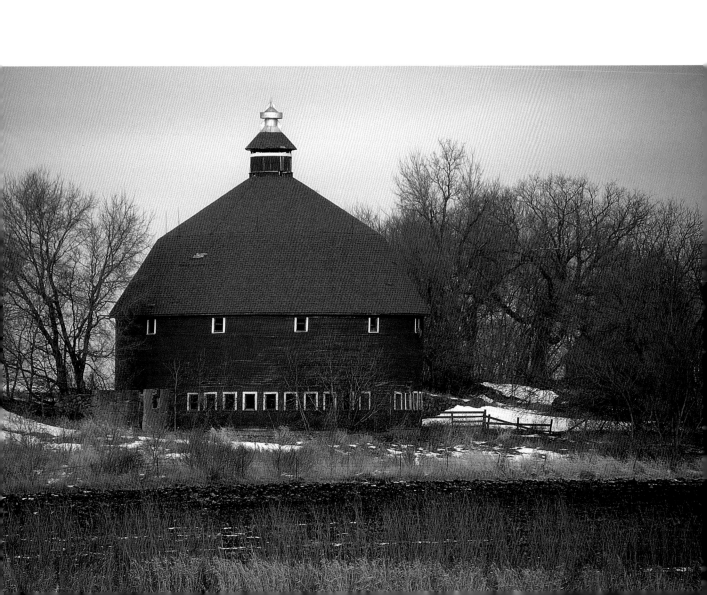

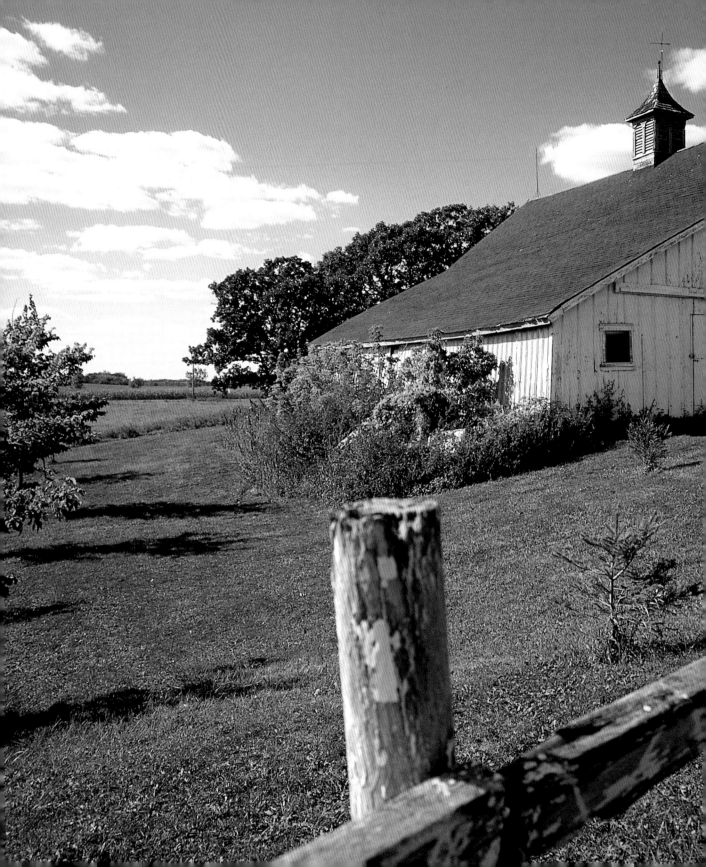

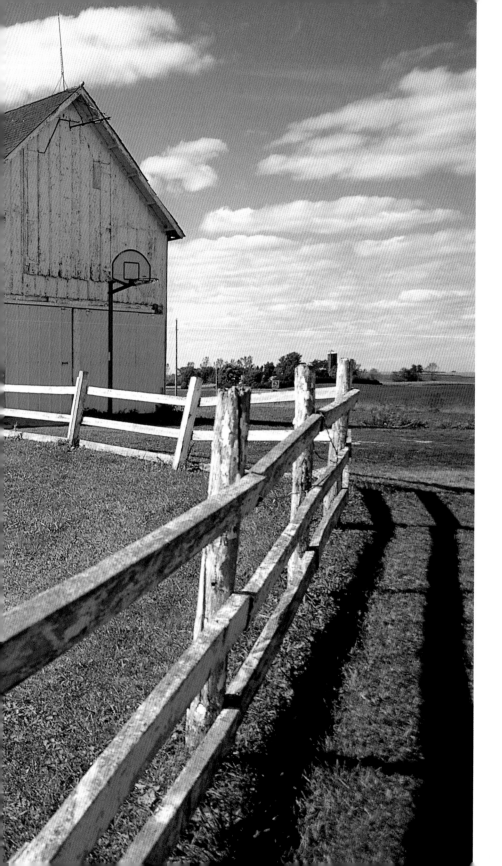

47

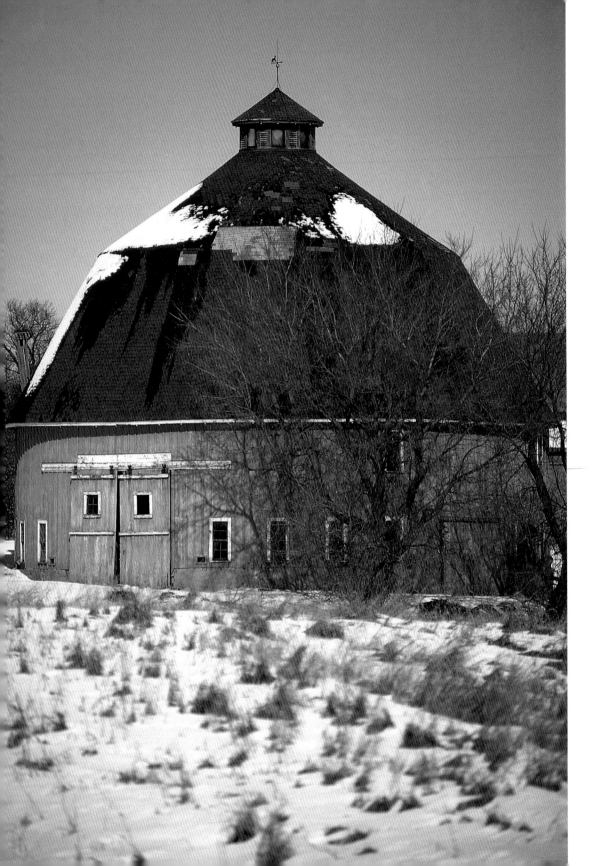

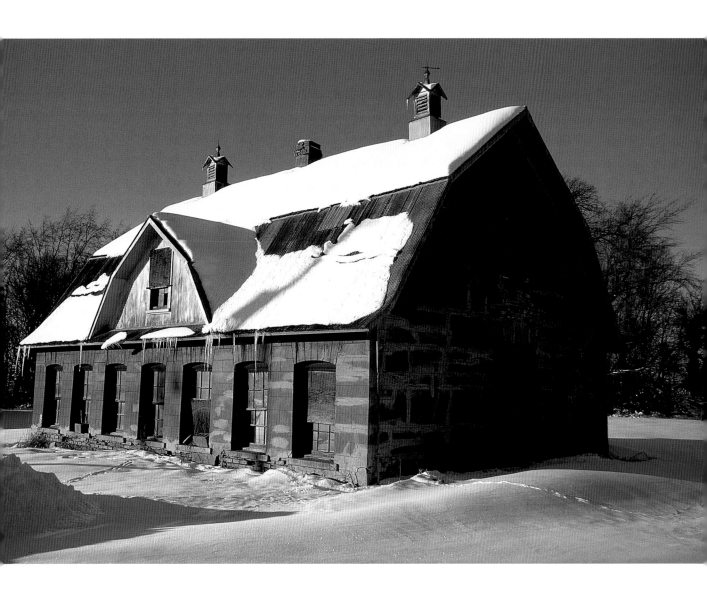

LEFT Chisago County, 1915. Known locally as the "Moody Barn,"
it has been saved from neglect and is on the National Register of Historic Places.

ABOVE Le Sueur County, 1920s, small gambrel-roof barn currently used as a storage shed

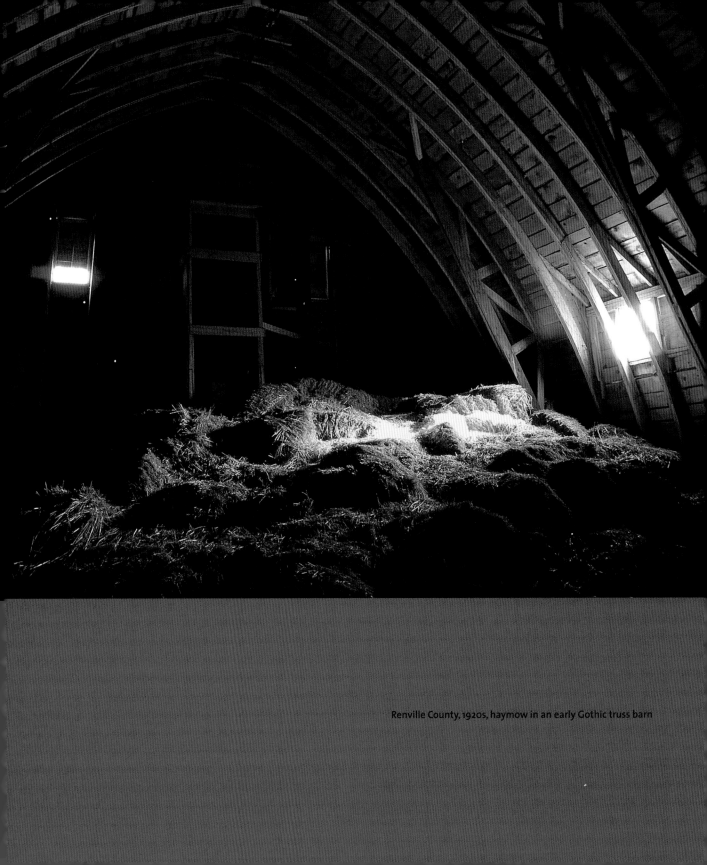

Renville County, 1920s, haymow in an early Gothic truss barn

1927 ▣ THE HIRED MAN

In November of the following year, Emmet's twenty-four young Holstein cows are milking well. According to plan he sold his hogs and bought bred heifers. From them he has gotten twenty calves, thirteen of which are heifers as well. He could not ask for better luck—until he arrives in the barn one morning and gets a great fright. ▣ The gutters are empty. ▣ They are beyond empty, it seems—they are unused. ▣ At first he thinks he might be still half-asleep. It is, after all, well before sunup. Both manure gutters are slick-as-a-whistle empty, which can only mean one thing: his cows are sick. The whole herd is bound up with some stomach disorder. Or worse, they have eaten poisoned hay, some sort of dangerous local weed that he knows nothing about. Yet, his black-and-white cows stand comfortably or lie in their stanchions like

always, chewing their cuds in their usual slow, side-to-side motion. They show no obvious sign of distress.

Then a second fright: there is someone in the barn. He is sure he saw a face duck behind the last cow at the far end of the barn.

"Who's there?" Emmet calls. He reaches sideways for his manure fork, which always hangs near the door on two nails, but his hand touches only shiplap barn wall. The fork and manure shovel are both missing.

"Hello?" Emmet calls, easing forward. No answer. There is only the rustle and thump of the cows, the clang and thud as they nose their drinking cup paddles in the warm, fragrant barn. Fragrant because the mangers are freshly filled with hay. Someone has cleaned the gutter and thrown down hay—all of Emmet's morning chores but the milking.

"It's okay," he calls as he walks slowly along the alleyway between the rows of cows. It's the only thing he can think of to say. Whoever knows how to clean a gutter and feed hay cannot be that dangerous.

At the far end of the barn, crouched behind the haymow ladder, is a small, shaggy-haired man in a greasy cap.

"Come on out, it's all right," Emmet says.

"I did the gutter. Threw down hay," the man says hoarsely. His voice is rusty, as if he seldom uses it.

"I see that," Emmet says. "Now stand up so I can see you."

He is a short, wiry man whom Emmet recognizes, but cannot place. Then it comes to him. "Ralph?" he says. "Ralph LeVeq?"

"Not LeVeq. That's *his* name." He has a slight stutter.

It is Ralph, Al LeVeq's retarded brother-in-law. "You were here when we raised the roof," Emmet says.

Ralph nods again. He stands straighter, but looks ready to run any second. His clothes are thin and tattered for November, and his cheekbones stand out. His hair is cut in bowl-style and his battered fingers are clenched around the handle of Emmet's manure fork.

"Trouble over at Al's place?" Emmet says suddenly. Something has gone bad—illness or fire—and Ralph has come for help.

"No trouble," Ralph says.

Emmet stares. Ralph looks like he has aged ten years since the barn raising two summers ago. He is skinny as a crow.

"Have you had breakfast?" he asks.

Ralph is silent. "I did the gutter, threw down the hay," he repeats.

"And I thank you for that." Emmet scratches his head. "Tell you what Ralph, you stay here. I'll go back to the house and bring you some food."

"He don't know I'm here!" Ralph says.

"That's fine. He doesn't need to know—not right now anyway. You stay until I get back, you understand?"

Ralph nods. He looks around, as if for more work.

"If you want to break a couple straw bales and freshen up underneath the cows, that'd be helpful," Emmet says.

Ralph scrambles up the ladder like a barn cat. Straw bales begin tumbling down before Emmet has left the barn.

In the house, Clara is startled to see him back already. "Is everything all right?" she asks. She

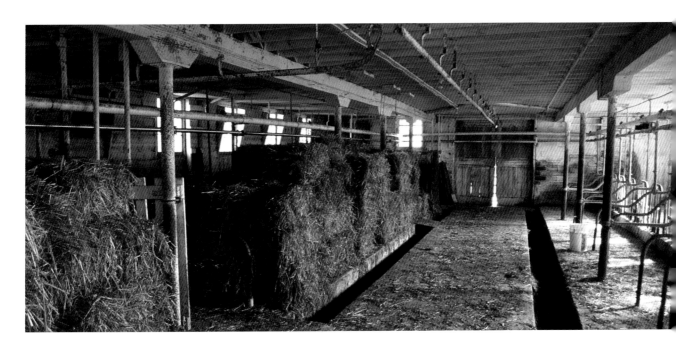

Waseca County

can see in his eyes that something is amiss.

"Well . . . ," he begins, and tells her.

"I just knew it!" Clara says, as if angry with herself. "I could see trouble in Al's wife, Sonya. She was so down in the dumps when the barn was built she hardly said a word the whole three days she was here."

They are silent. "So what do we do?" Emmet says.

"First things first," she says, bustling about the kitchen. She makes Ralph a plate of food including bread, cold meat, and a couple of fried eggs. "After chores bring him inside and we'll get him cleaned up."

Back in the barn, Emmet's cows have never had so much fresh straw. They are swimming in it, rolling their big bellies and udders in it; several of them have stretched their necks around their stanchions and have taken big mouthfuls to chew.

"That's a great plenty of straw," Emmet says.

Ralph hunches his neck down as if Emmet might strike him.

"On the other hand, it will last them a couple of days," Emmet adds.

Ralph's gaze falls to the covered plate.

"Here. You eat while I get to milking," Emmet says. When he looks back over his shoulder, Ralph

is scuttling off to his hiding place under the haymow ladder. He crouches there and stuffs his mouth until his cheeks look like a pocket gopher's.

Emmet milks by hand with long even strokes that tinkle, then splash hot milk in the bright stainless-steel pail. Ralph comes over and stands close by, watching.

After awhile he says, "I can milk."

Emmet glances at Ralph's black, dirty hands. "No, I'd best do it," Emmet says, "at least for now."

Ralph stares at the hot milk squirting into the pail. As the pail fills he can't take his eyes off it. His Adams' apple bobs.

"There's a tin cup over by the spigot," Emmet says.

Ralph hurries to get it, almost knocking over

the waiting cream can. Emmet pours from the milk pail into the can, but saves a quart in the bottom of the pail. "Hold out your cup," he said.

Ralph thrusts it forward.

Emmet pours the cup full, and Ralph gulps down the warm milk in one, long draught.

"More?" Emmet asks.

Ralph holds out his cup again. He drinks close to half a gallon.

In the house, after milking, Clara sucks in her breath at Ralph's condition. His tattered clothes. His hands. His neck with rings of grime. "Hello again, Ralph," she says.

Ralph is silent but smiles ever so slightly.

"Welcome. But no caps in the house," she says. Ralph snatches off his cap, then itches his head. White lice crawl on his ears.

"Oh dear," Clara murmurs. "Let's get you out on the summer porch," she says easily, as if nothing is wrong. "There's plenty of hot water from the reservoir. I'll have Emmet bring a bucket out to you. I'm going to get you some better clothes, all right?"

"These are his clothes. All he gives me are *his* clothes!" Ralph blurts with sudden anger.

"And we're getting rid of them," Clara says. Emmet is amazed at how well she handles Ralph.

She would make a good teacher, he thinks.

On the screen porch alone with Emmet, Ralph's anger at Al LeVeq's cast-off clothes trumps any modesty; in a minute he is naked and shivering. He looks like a skinned squirrel. Emmet pours a full pail of hot water into the copper tub. "Use plenty of soap and that scrub brush," Emmet says, and leaves him be.

Inside, Clara whispers, "We have to do something about that lice." She sets out a bottle of vinegar while Emmet goes to the barn for his cattle clippers. An hour later Ralph's clothes and cap are flaming in the burner barrel, and on his shaved head he wears a turban: a towel soaked in vinegar, then a dry one wrapped tight around that. Ralph wrinkles his nose at the odor.

"Yes, it smells, but you have to wear that overnight," Clara says sternly. "It will kill all those bugs. Then we'll wash your head again tomorrow."

"Okay," Ralph says. He smiles for real this time. He is dressed in a set of Emmet's old but clean woolen underwear from which Clara has cut at least six inches from the sleeves and legs.

"I'll hem them later. They'll do for now." She does the same with a set of overalls and a flannel shirt. Afterward, Ralph looks around the house and into the kitchen, as if hungry again.

"Well, Emmet," Clara whispers, "now what?"

The "Now What?" is complicated. Emmet's first idea is to ride over to LeVeq's place. Let him know where his brother-in-law is. Ralph is, technically, a runaway.

"Then what?" Clara asks.

Emmet is silent.

"I think we need to go to town and talk to the sheriff," she says.

Sheriff Bob Patterson, a tidy fellow younger than Emmet, is not unsympathetic. "That Alphonse LeVeq is no good. He steals traps and anything that's not nailed down. We've had trouble with him before."

"I don't think he treats his wife any better than poor Ralph. The man ought to be in jail," Clara says.

The sheriff blinks at that and tips back his short-billed official hat. "Now that's a matter between a man and wife," he says, "—but we'll keep an eye on him." He adds the last part quickly, for Clara has raised a finger and opened her mouth to speak.

"Anyway, what do we do about Ralph?" Emmet says quickly.

The sheriff jingles his keys on his belt. "I'd best go over and talk to LeVeq."

That afternoon the sheriff comes by car into Emmet's yard. He has a passenger, Sonya LeVeq, in the front seat. She won't look up or get out. Her unkempt hair falls forward, curtaining her face.

"It's not good over there," the sheriff says. "He's boozing hard. I'm sending his wife to her sister down in southern Minnesota."

"Good!" Clara says. Emmet puts his hand on her arm.

"And Ralph?" Emmet asks. Ralph's round head disappears from the barn window.

"If you'll take him, he's yours," the sheriff says.

Emmet and Clara look at each other. "We don't have much room in the house," Clara says. Emmet purses his lips.

"He could stay in the barn," Emmet says.

"No," Clara says decisively. "Think what people would say. We'd be no better than LeVeq."

They are silent.

"He can stay," Clara says. "We'll make do. We'll figure out something."

The sheriff nods. "If LeVeq makes trouble, you come to me."

Al LeVeq arrives on horseback two days later. Word has spread. "Where is he? Where is that *retard*?" he shouts at Emmet. He has a rifle, a Winchester carbine in a scabbard.

"Where is who?" Emmet says. He gets up close enough to grab the rifle if need be.

"You know damn well who. Ralph. Tell him to get his butt out here. We're going home." Emmet can smell liquor on LeVeq.

"Ralph is not going back," Emmet says.

"What?"

"He's staying here because you treat him like a dog," Clara says. She has come up behind Emmet—when he told her to stay in the house.

"Why you!" LeVeq takes a drunken kick at Emmet, who dodges the boot and grabs LeVeq's leg at the same time. LeVeq tumbles off his horse and tries to grab for Emmet. As Emmet pins LeVeq in the snow, Ralph rushes out of the barn with a three-tine hay fork. "No, Ralph!" Clara shouts.

Ralph is but a few feet from running LeVeq through, but halts at Clara's command and up-raised finger.

LeVeq, his nose bloody, looks up blearily from the ground. Emmet grabs the Winchester and jacks out the seven shells. He puts them in his pocket. "I'll give these back to you some day when you sober up. Right now, get your horse, get down the road, and don't ever come back."

Muttering in French, tilted forward in the saddle, LeVeq disappears down the road. He doesn't look back. It's as if he has forgotten why he came in the first place.

"Well," Emmet says, dusting off his big hands. It's all he can think to say, because his blood is up, his voice untrustworthy.

"Welcome to your new home, Ralph," Clara finishes. ▣

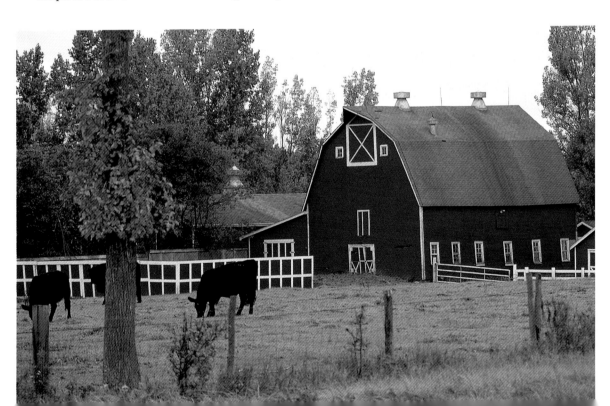

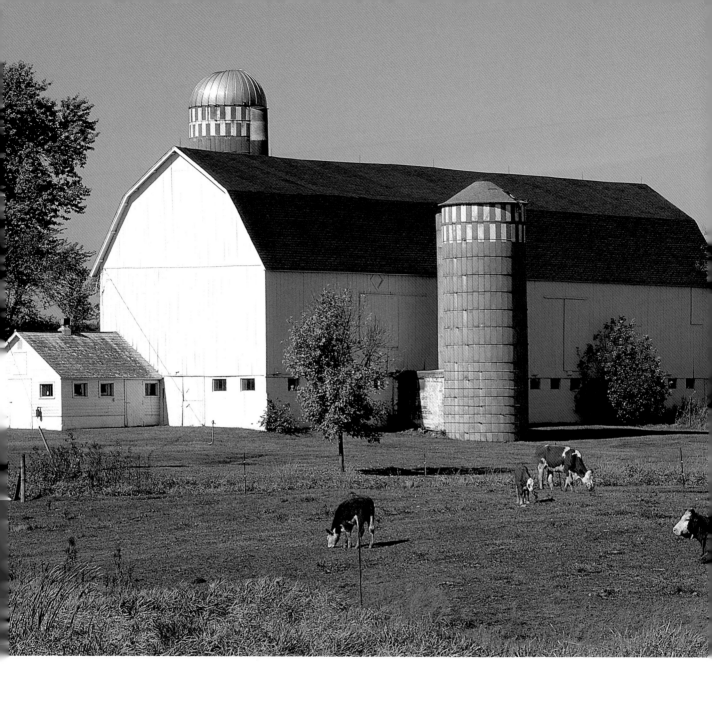

ABOVE Hennepin County, 1930s. When the barn, one of the largest in Hennepin County, was recently painted it was said to take 120 gallons to finish the job.

RIGHT Morrison County, 1874, the horse stalls at the historic MacDougall Barn. Note the log-cobbled stall floor.

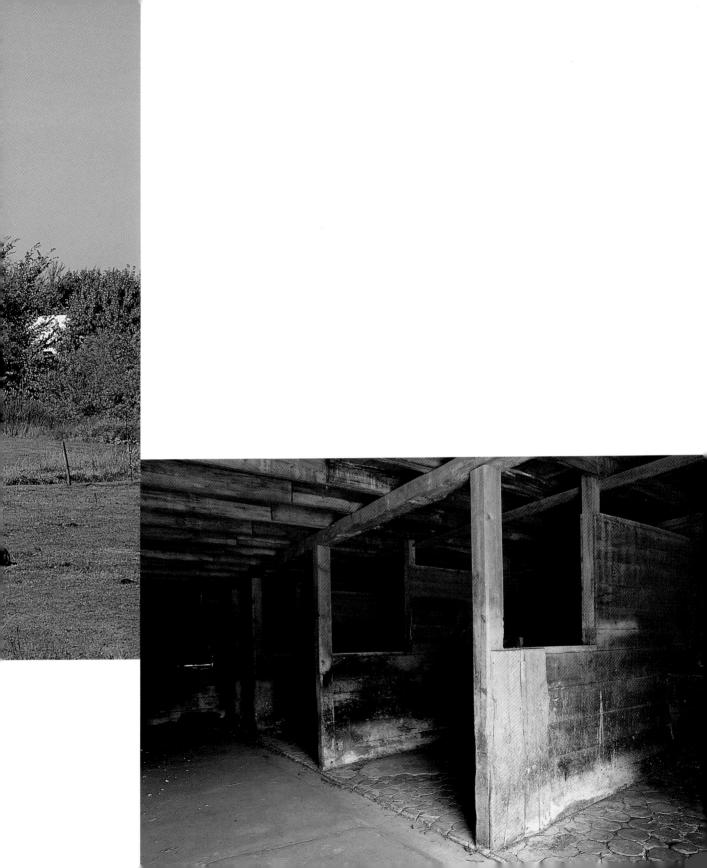

BELOW Washington County, 1880s, large post-and-beam barn with a poultry shed addition

RIGHT Waseca County

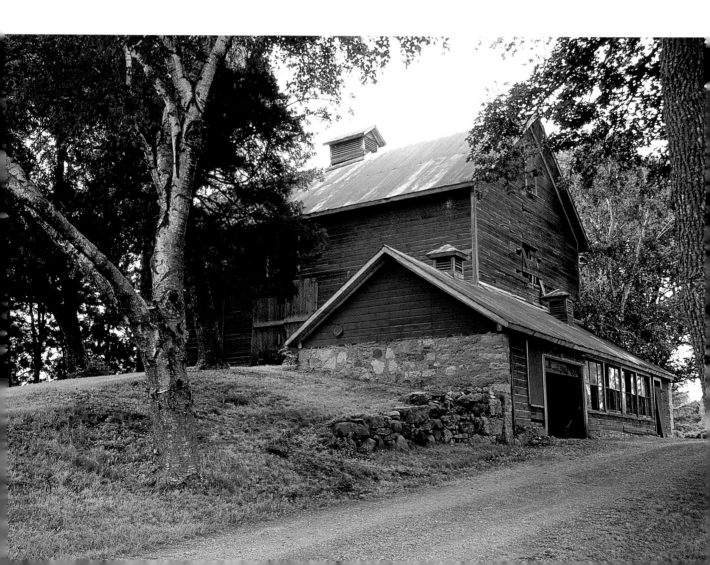

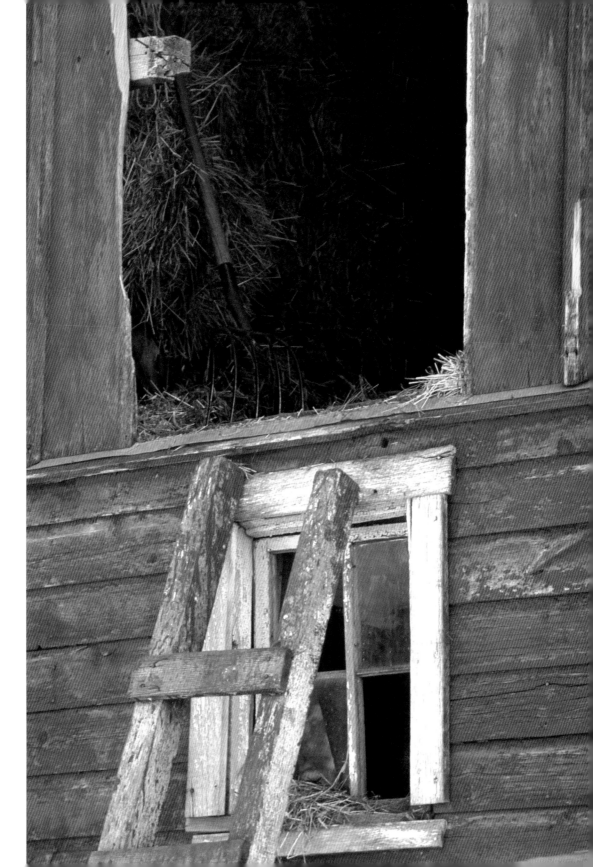

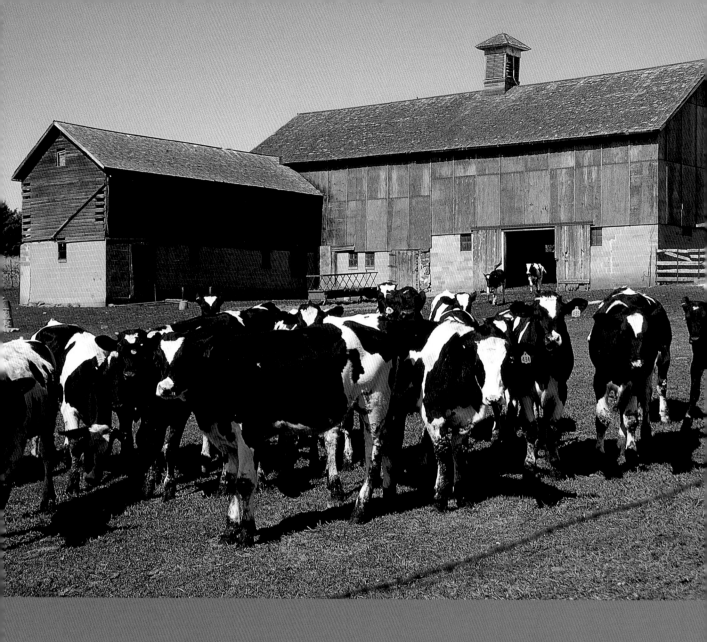

Waseca County

1928 ◙ BARN LIFE

Because of Ralph, Emmet has no excuse not to build the new house, which he does the next summer of 1929. There is a small bedroom for Ralph upstairs, with a window where he can keep an eye on the barn. He gets up earlier even than Emmet—earlier than anyone he and Clara have ever known. It becomes a problem. ◙ "Why do you get up so early?" Joseph asks Ralph during breakfast. At first Joseph was afraid of Ralph, but now he understands him. Plus he has been listening to Emmet and Clara talk. "Poppa says the cows hardly get to sleep." ◙ Clara pushes Joseph's leg hard with her foot. ◙ "It's true, that's what you say?" Joseph cries back. ◙ Emmet and Clara try not to smile as breakfast continues. ◙ "I have to get up early because of the *nisse.*" Ralph looks directly at Joseph as he pronounces the name solemnly: "nee-saw." ◙ "Nisse? What are nisse?" Joseph asks.

"Trolls. Ugly trolls that live in the hayloft. If you don't get there early, the nisse will suck the cows dry." Ralph never doubted the Norwegian legends he first heard as a child.

Joseph's eyes widen, as do Emma's. Little Dorothy gets a scared look on her face.

"That's quite enough of that, Ralph," Clara says. "You're scaring the children with that old Norwegian stuff. And besides, nisse are friendly elves, not trolls."

Joseph eyes remain as round as pullet eggs; he is no longer hungry. "Poppa, are there really nisse in the hayloft?"

"No. There are no trolls, no elves, no nothing in the hayloft besides barn cats and pigeons."

"And barn owls," Joseph adds.

"Yes, once in awhile," Emmet allows.

"And mice," Joseph says.

"Yes, a few."

"So maybe there are nisse."

"No. No trolls, no nisse, no nothing in the loft!" Emmet says, and thumps the table with his hand so loud that Dorothy begins to cry.

In the meantime, Ralph has helped himself to the rest of the bacon.

"Anyway, Ralph," Clara says, "Emmet and I have decided. You must stay in bed until at least five A.M. every morning."

"Okay," Ralph says easily, his eyes on the toast.

It is not all peaches and cream having a hired man. Ralph is extra work, including the cooking and laundry. He will not change his underwear until Clara asks him for it, and so she sets up a schedule when Ralph must give up his long johns, marking an X on each Saturday of the calendar hung in the summer porch. And once when she was putting away his clean clothes in the little pine dresser, her hand touched something soft and smelly—she jerked back her arm. It was a block of moldy cheese and behind it a row of bread crusts. She looks further in his dresser and finds dried leftovers at the back of every drawer—crusts

cheese are Ralph's hedge against hard times come again. In her heart she knows this, but still. A hired man is not easy.

For Emmet, Ralph's presence is a blessing. Because of Ralph, Emmet has time to clear more land, selling the aspen and white spruce pulpwood for cash, which he spends to upgrade his tractor and haying equipment. Because of Ralph, Emmet has time to read and study dairy husbandry articles from the University of Minnesota in St. Paul, which he orders through the local extension office. He makes changes in his herd's nutrition, adding more soy protein to their diet. Milk production improves. He modernizes the barn with a vacuum line and a Surge kettle milker. Emmet and Ralph still use cream cans and the outside water cooler to keep the milk cool at 45 degrees until it's hauled to the creamery on Wednesdays and Saturdays. But no more milking by hand.

A natural division of labor develops. Ralph, who is much tidier these days (thanks to Clara), gradually takes over the milking and feeding of the cows, the cleaning of the gutters and the calf pens. Emmet manages the cows' breeding and everything outside, including the crops, machin-

65

hidden everywhere. She sits on Ralph's narrow bed and cries: she has not done enough, not fed him well. Emmet assures her that she has done a wonderful job; he says that the crusts and the

LEFT Hennepin County, automatic cow-watering bowls, or "drinking cups"

ABOVE Renville County, barn basketball

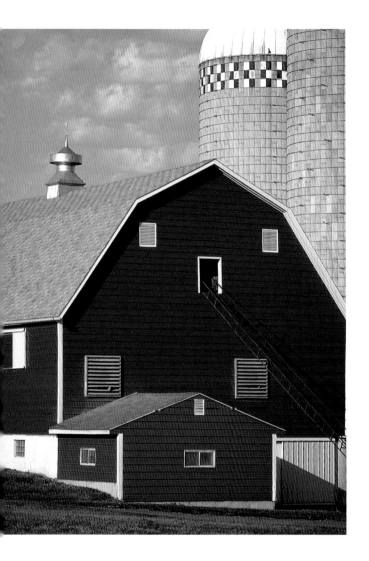

ery, and woodlot. He also buys an adjoining 160 acres, which annoys Ralph. Changes annoy Ralph, and he mutters in the evenings when Emmet pores over his *Hoard's Dairyman* magazine. Mutters and clips his fingernails loudly.

For Ralph is a moody man, though never when little Joseph is around. Joseph is Ralph's best friend, his playmate, his pride and joy. He watches Joseph like the red-tailed hawk that soars above the farm with its gaze always cast downward. Ralph has rescued Joseph more than once from high in a tree, from too far up the ladder on the silo. Joseph does not play in the shadowy hayloft, at least not alone, even though Ralph has made him a rope swing there. Only with Ralph will he go up there. Summer nights after chores Ralph pushes Joseph on the hayloft swing for over an hour. Clara and Emmet, sitting on the porch, listen to Joseph's shrieks of pleasure and Ralph's hoarse laughter. "Goodness," Clara says, but they never really worry about Joseph when Ralph is around.

Because of Ralph, Emmet spends more time with Clara, sleeping in an extra hour in the morning, "their time" they've come to call it, when the three children are sleeping. Spending almost too much time with her, he thinks, for she has just

LEFT Stearns County, 1920s

RIGHT, TOP Waseca County, 1892, handmade cupola

RIGHT, BOTTOM Chisago County, 1930s, twin barns near Rush City

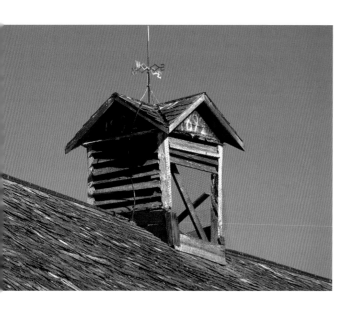

tracks in search of agates on the gravel bed and arrowheads in the freshly plowed fields. When he traps gophers in the summer, he takes along his baby brother, Lyle, pulling him in a little red wagon. Joseph is good with children. He is a warm, quick, slender, lively boy who looks like his mother. Joseph is an outdoors boy, a boy who looks often to the sky and sees things—hawks, eagles, geese, the moon—that Emmet misses. At night after his school work is done, he reads endlessly about aeroplanes. ▣

told him that a fourth child is on its way. But the children—and Ralph—are all blessings.

Because of Ralph, Joseph does not work in the barn. Well, some, but only token work such as bottle-feeding the smaller calves after school. He does not clean calf pens or fork down silage like the other farm boys. He does not have to clean the gutter every morning before school or help with dehorning and castration of the bull calves in the spring. Because of Ralph, Joseph plays more, explores more. He ranges far down the railroad

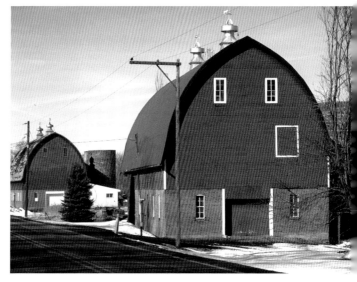

BELOW Waseca County, 1926, large Gothic dairy barn

RIGHT Washington County, 1880s, early Swedish barn. The large sliding door on the side of the barn was positioned off-center.

NEXT PAGES Dakota County. The left barn was built in 1927. To meet the needs of the expanding dairy operation the second barn was constructed in 1942.

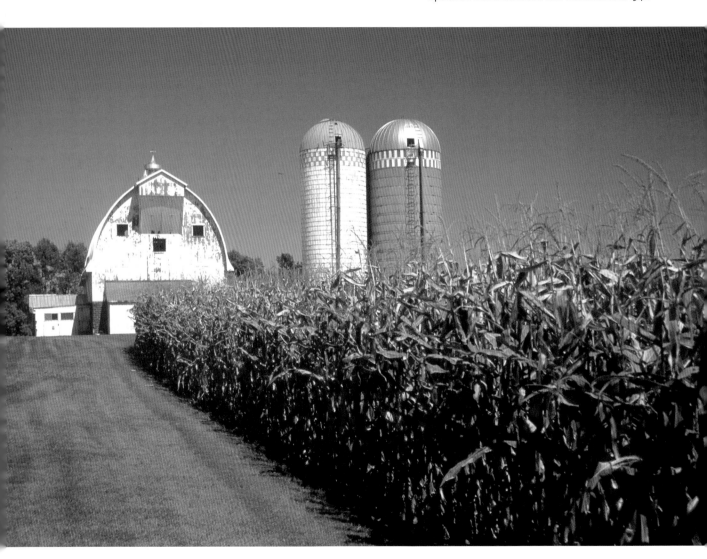

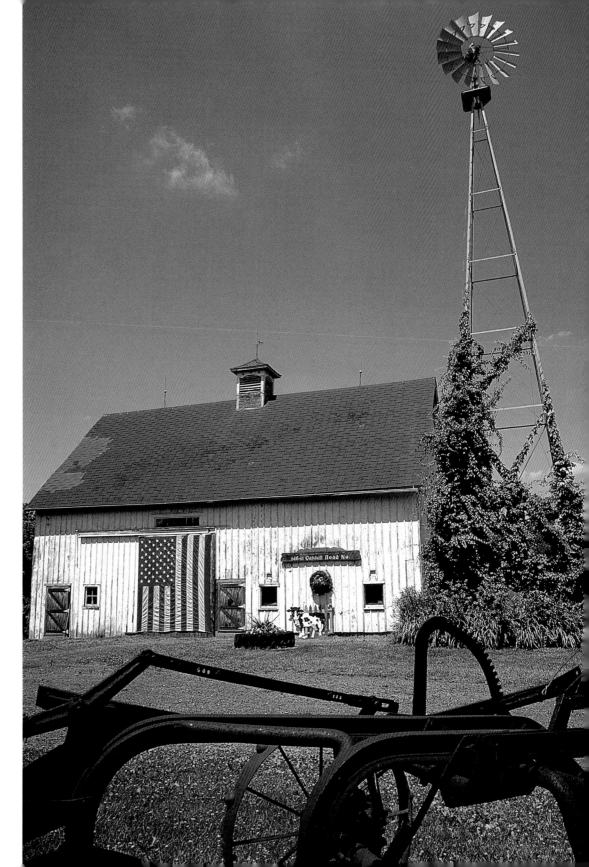

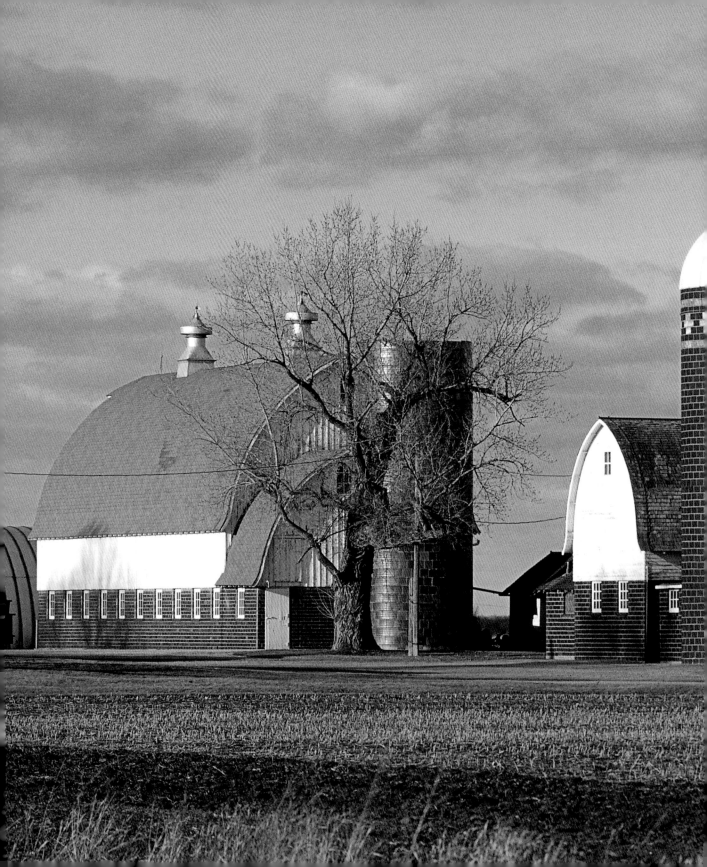

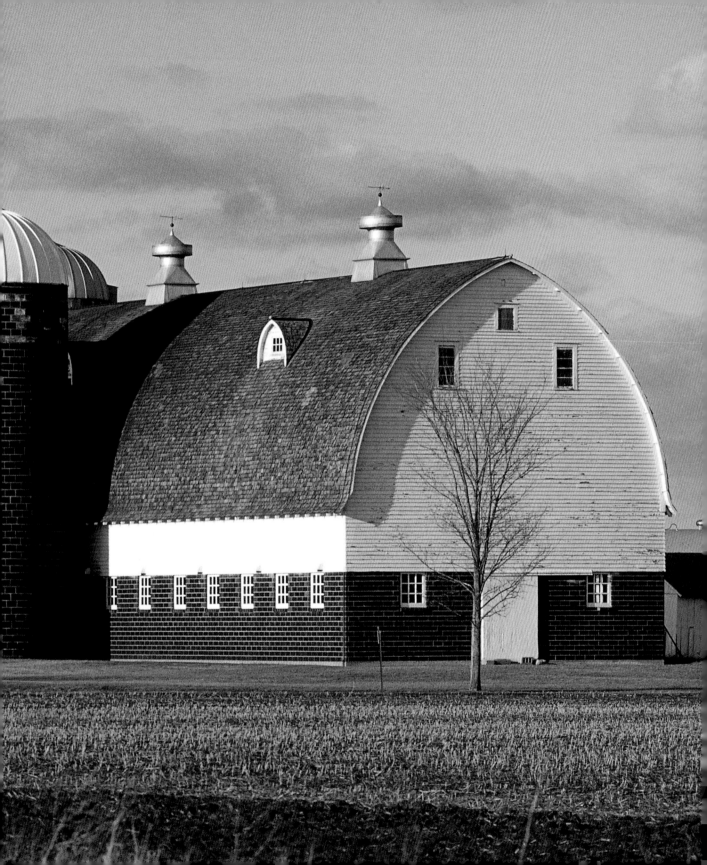

BELOW McLeod County. "The Pink Barn" has been pink since the barn was built in 1904.
The current owner has painted all his outbuildings pink as well.

RIGHT Scott County, 1900s, a turn-of-the-century threshing barn still in use on a suburban hobby farm

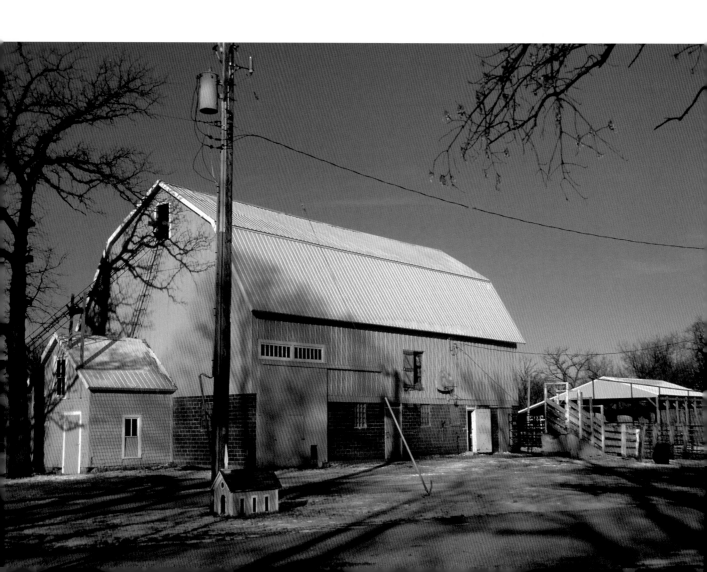

Kanabec County, 1920s

1944 □ WAR

On September 27, 1944, Airman First Class Joseph Anderson is the navigator in a B-17 "Flying Fortress" over Germany. They have successfully bombed the Opel tank factory in Cologne and are turning back to England—when there is a tremendous explosion. A cold, tidal wave of air and chaos overtake the plane. □ Flak. □ Or a German fighter. Something has hit them. Joseph is temporarily without oxygen, but manages to find his little tank and fits on the mask. He cannot hear; something has happened to his eardrums, and his right arm is bloody and does not work well. Everything is like a silent movie. The plane, with a wingspan of 103 feet, shudders like a car with square wheels on a steep bank, but steadies after it completes the turn toward England. Toward home. But the pilot is shouting and soundlessly pointing behind Joseph at gathering black smoke above a flicker of flames. At more

than two hundred knots, the cold air fans the fire like a blowtorch, and aluminum begins to melt and run like solder, like quicksilver. Another ten minutes will get them well into Belgium, Joseph knows, but they have less than that.

Somewhere near the German border, Heinsburg or Limburg, they bail out. Only three parachutes hang in the sky, which is now more silent than inside the plane. There is nothing quieter than hanging from a parachute above green farmland. It is September, and the trees are turning color and the rock fences are gray and the villages like scenic postcard pictures. Like illustrations in a children's book. . . .

Joseph wakes when he slams onto the ground—hard. His legs buckle and one breaks, but he is alive.

And not far off is a barn. A gray, stone-walled barn with a tile roof. Its narrow windows remind him of the castles and stone houses in England, but no, this is clearly a barn. Much of his body does not work well, but he manages to crawl away from his tangled lines and make his way to it.

The barn is abandoned. Empty but for some rusty old scythes, wagon wheels, smashed barrels, and mouse-chewn horse tack hung on wooden pegs. The barn is full of cobwebs and silence.

In one of the pens the straw is old and musty but soft, and Joseph falls onto his back and lies there. Some of the roof tiles have come off; light shines down through the mote—long fingers of bright dust. He tries to get his breath, but there is something sharp in his belly and chest, and blood inside his shirt. The smell of the barn is the same as home. All barns smell the same: of old wood, straw, dried manure, the animals they housed. He wonders how old this barn is. It is definitely much older than the one back home. Its beams are heavy and notched perfectly in some kind of joint—called a mortise and something. He should know the name of that joint, should know how a barn is built, but he never paid close attention to his father's barn. It was always just there. But now he has time to look.

His gaze traces the lines of the rafters, their angles; how symmetrical they are! There are perfect, repeating triangles in the frame of this barn, and he closes his eyes just for a minute in order to better remember his father's barn. Closes them because there is more pain now, a heavy, squeezing feeling, in his chest. He concentrates upon calling up exactly his father's barn.

From a distance, the wide face and great haymow door. And a lower Dutch door, as his father

called it: bottom half shut, top open where Ralph often looked out when Joseph was riding his bike and playing baseball in the yard.

A few feet above the front door, a smaller, narrow door about four feet wide and six feet tall, a recent addition, his father added when they went from loose hay to square bales. Cut in the front of the barn, this is where the bale "elevator," or conveyor, angled through.

Several feet above that, the wide mouth of the great door. At least sixteen feet tall, and only slightly narrower, it swung down like a giant mouth opening, a jaw slacking, to swallow up the loose hay. Above it, at the very top was the overhung peak shading an iron track and two-wheeled trolley.

He has been hanging around Brits too much,

but trolley is the best word he can think of. A trolley with a dangling sling that lifted loose hay from the wagons below. The clutch of hay was hauled backward by rope and pulley to the rear of the loft where it was dropped onto a mountain of loose hay.

He barely remembers this, not because of the pain right now, but because he was young then. Much sharper in his memory are square bales (rectangular, actually) cinched with wire. With square bales he was of some use to his father and Ralph. He helped with haying not in the loft where it was hot and stuffy, where Ralph stacked towers and cliffs of bales, but on the hay wagon. Joseph tipped the heavy bales onto the elevator, watching them "clack-clack" upward until they disappeared through the small narrow

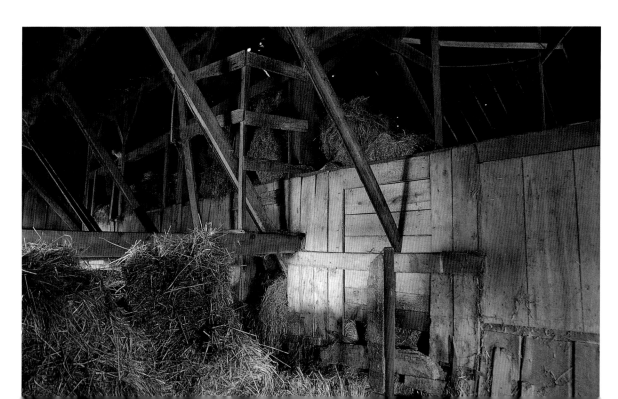

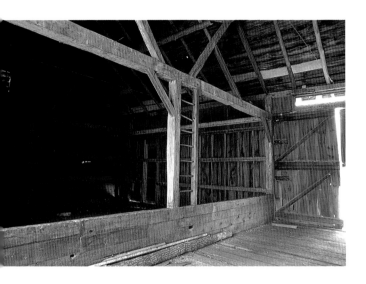

door where Ralph waited. Sometimes for a trick he loaded up the elevator with ten bales back to back—so close they were touching—then waited to hear Ralph swearing.

"Sorry, Ralph!" he would call up, and Ralph would always forgive him by supper time, or close after.

In winter Ralph dropped the same bales down through the hinged doors in the haymow floor, then jumped down to break them and fork the hay fresh and dry-green into the mangers. Afterward he hung their wire on pegs on the wall, a spotted, splattered whitewashed wall (lime, water,

and fly spray, and a name for the mixture that will not come to him). . . . In winter it was always warm inside the barn. There were no electric heaters, no furnace in the barn. The warmth came from the big Holstein cows, twenty-four of them, two rows of twelve, butts out to the common alley between, the gutters tufted with "cow pies" and straw. With the haymow floor insulated by layers of bales, the barn stayed comfortable even when it was twenty below zero outside. A humid, close, rich warmth.

And the cows themselves, the swinging switch of their tails, and above each cow a square-framed name plate ("Sylvie, Betty, Dolly") that include date of birth, bull's name and when bred last, when "fresh." Along the beam above the stanchions the barn cats Beezer and Leo (which was the shy one?) lay there watching the milking, hoping for a spill.

And in front of the stanchions, the mangers full of hay or silage. The forks hung on the wall: three-tined pitch fork for hay, four-tined manure fork, and the wide silage fork with six tines? No eight—he was sure, eight.

But he is forgetting things. In the corner by the front door, the tiny pump room for the vacuum compressor hooked to the line that ran above the cows, a petcock for each. The oily cylinder ribs of

78

Morrison County, 1874, the drive-through bay in one of the state's oldest remaining four-bay barns

the compressor furred with dust. The small, orange Surge oil can at the ready. To one side a shelf with a square, gallon can of fly spray; a hand-pump fly-sprayer with its screw-on glass jar. Also on the shelf the dehorning shearers, plus cans of "Blue-Kote," an antiseptic for castrated bull calves, and pine tar for use after dehorning. Below the shelf a flat, drop-leaf metal box where his father kept the breeding charts on his cows. In the corner smooth, broken fork handles that Ralph would never throw away.

And the milk house with its steam and clatter of cream cans, and floor drain, wash tubs and racks for the Surge milker and its parts, and the four-fingered rubber teat cups that hung like hands as they dried, and later the big bulk tank—big as a silver buffalo—with a heavy lid and paddle that churned to keep the milk from separating. The little mailbox-sized double door in the wall where the milk truck driver fed through his hose, which was black and thick as a man's arm; how it sucked out the milk, then snaked back through, and the driver speared the milk ticket on the nail just inside the door, then rumbled away.

And the silage room that connected the barn to the adjacent silo, how it smelled like vinegar, like a brewery, like an English pub. The square wooden doors of the silo stacked in the corner according to how far "down" the silo was. In late fall, Ralph climbed up every day and threw down showers of the chopped, fragrant brown corn. A steaming mound grew, and little wheels—slices of corn cobs—rolled down the sides, and barn cats played and chased them as if they were mice. Joseph would call up the metal chute, asking if Ralph were done, done so they could go into the hayloft and play. Because after all was said and done, there were nisse in the hayloft.

He had always been afraid of the nisse.

Until now.

On his back, Joseph looks up into this barn somewhere in Belgium or maybe still in western Germany. The barn has shadows, and dark places, and ghosts, but he is not afraid. He knows the smell; the straw is soft; the high and arching emptiness is a comfort. He dreams for awhile, until something rattles the door—a flash of light, perhaps an explosion of some kind. Light floods in.

Lifting up his head, he sees in the doorway the silhouette of a man. A man with a round head, and carrying a fork or something in his hands, and others behind him. Joseph lies back and smiles. It is Ralph. Ralph leading the way. Ralph come to save him at last. ◘

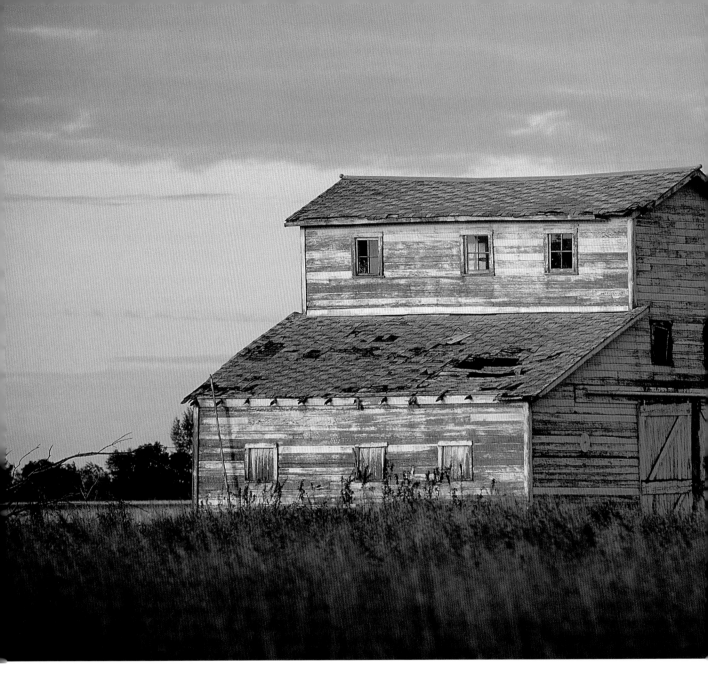

ABOVE Marshall County, 1922, grain barn in the Red River Valley

RIGHT Waseca County, 1920s, self-supporting rafters allow for a wide-open haymow

NEXT PAGES Pine County, 1920s, large hay door inside gambrel-roof barn

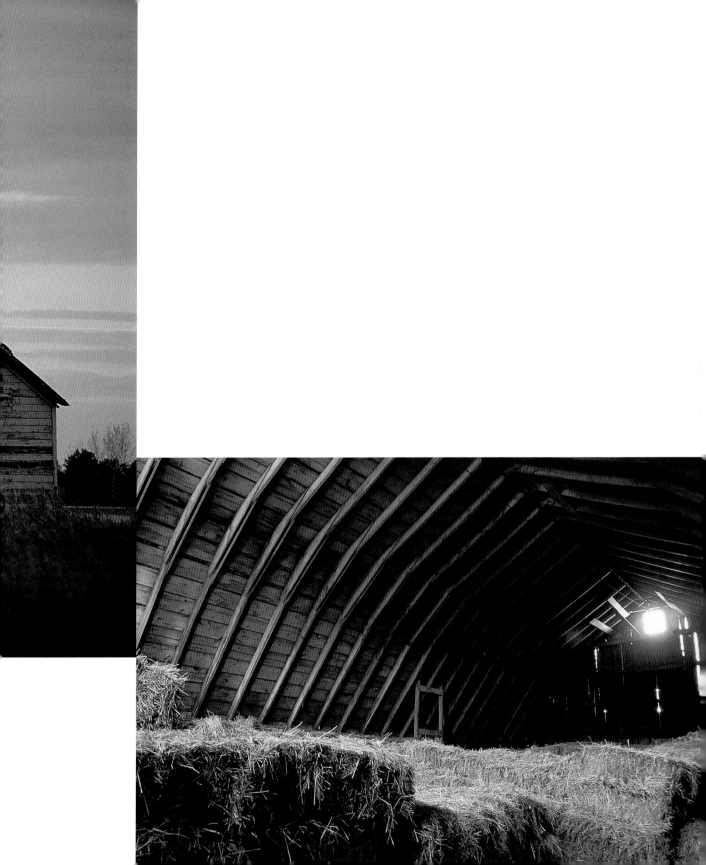

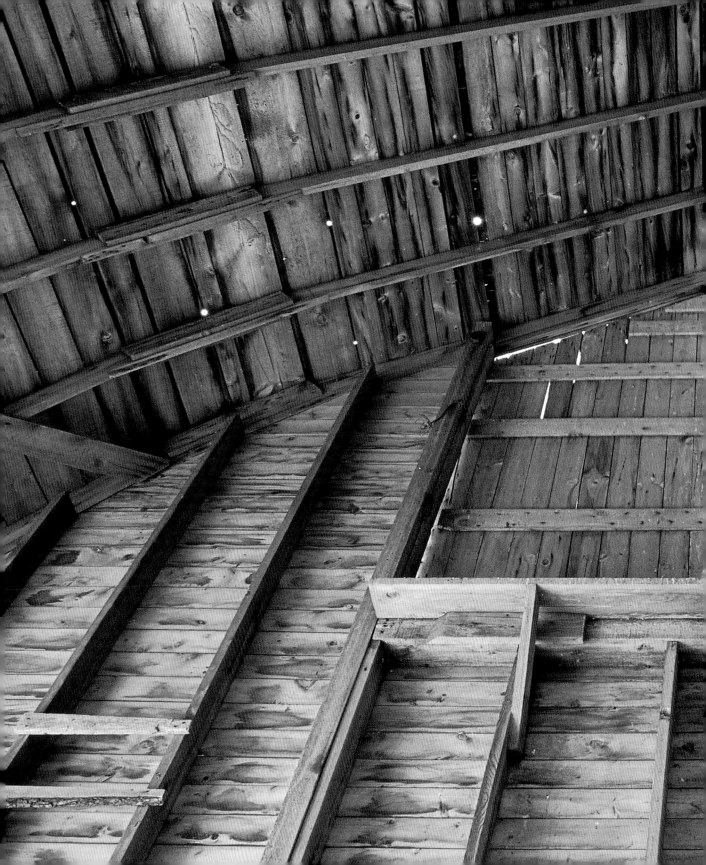

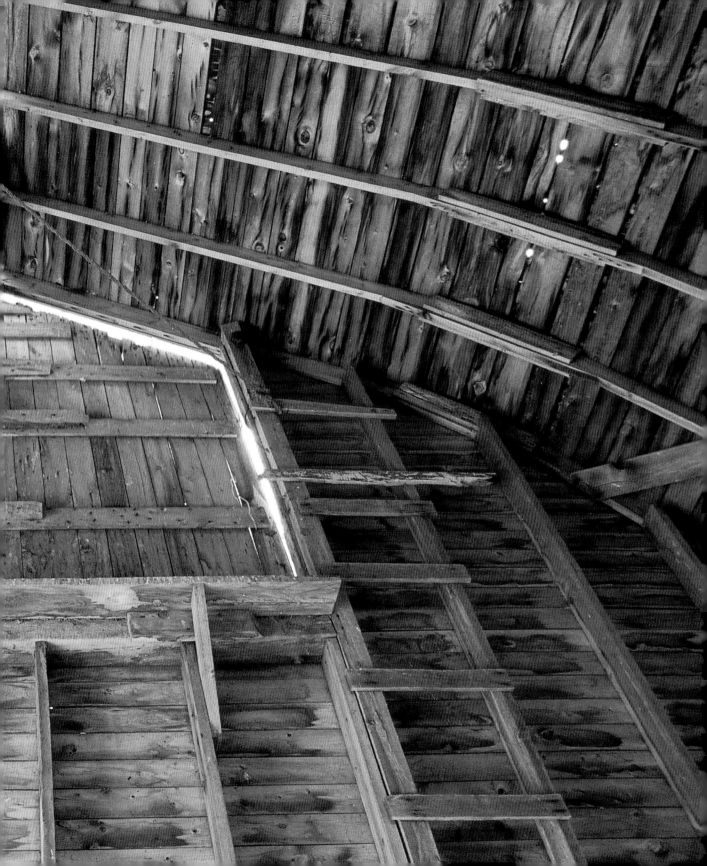

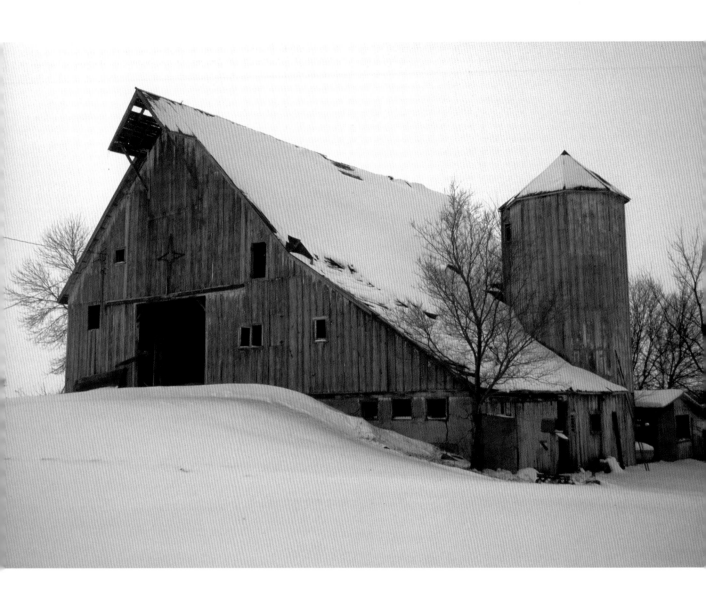

ABOVE Lac Qui Parle County, 1890s, large Dutch barn

RIGHT Becker County, 1920s, Gothic barn

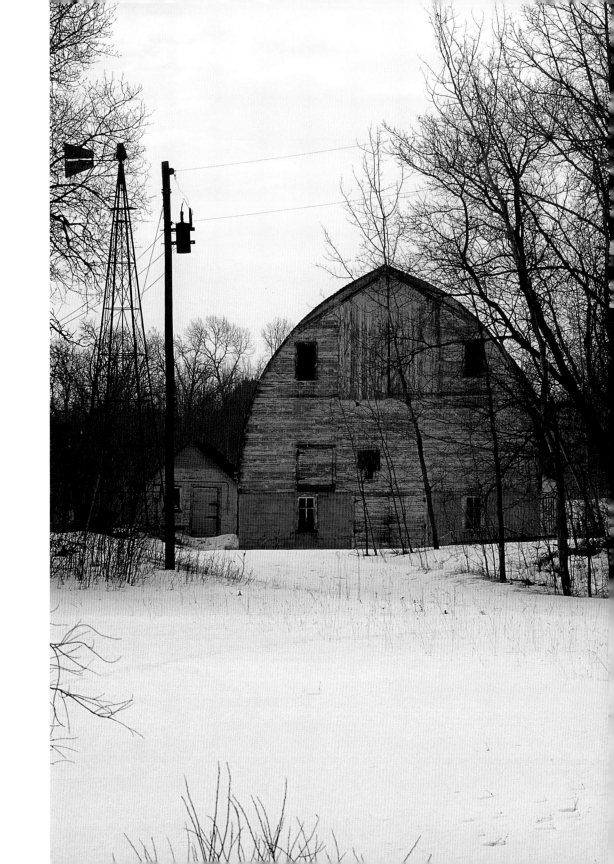

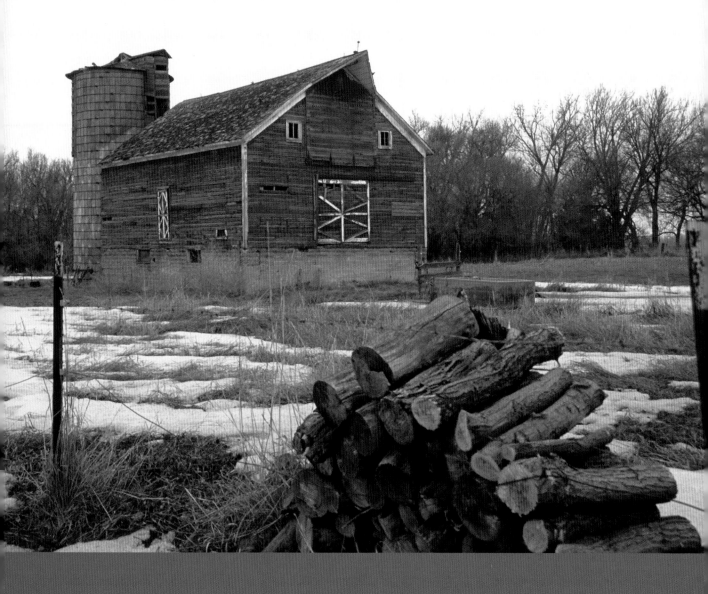

Clay County, 1912, small foundation barn

1944 ◙ LIFE AND DEATH

At Emmet and Clara's farm on October 18, 1944, a bright autumn afternoon, the sheriff's car comes slowly up the driveway. Ralph is first to see it. The dusty star on the side. The red gumball machine on top. He peeks out around the side of the Dutch door as the sheriff gets out of the car and comes toward the barn. Ralph hightails it to the hayloft. It's about LeVeq, he worries. LeVeq is coming back. ◙ "Emmet? You here?" the sheriff calls into the barn. There is silence. Ralph hears him go through the swinging doors into the milk house. Finally the sheriff goes away. When Ralph peeks out again, the sheriff is walking out to the field where he has heard Emmet's tractor. ◙ Ralph watches. The sheriff waves down the tractor. It slows and stops; the engine dies. The sheriff hold out a piece of paper to Emmet. Emmet stares from his perch on the tractor, then bends down to take it. He opens a small

envelope, reads the note, then puts his head on the steering wheel. His forehead, between his hands, on the steering wheel. Nothing happens for a long time, until the sheriff clumsily climbs onto the tractor and puts his hand on Emmet's back. He holds it there under the still sun. Eventually the sheriff helps Emmet get down off the tractor. He does, slowly, like an old man, and then the two come walking back toward the barn. Ralph gets ready to run, out the back door and through the woods. He can walk the railroad tracks to town. Take the Greyhound bus. He has a few dollars hidden in the hayloft.

But Emmet and the sheriff do not come to the barn. They pass by, Emmet carrying the paper and his cap in hand. His head looks very white in the sunshine, like a skull.

By now, Clara has come out of the house. She is wearing an apron that is dusty with flour. Emmet slows his walk as he gets close to her. She sud-

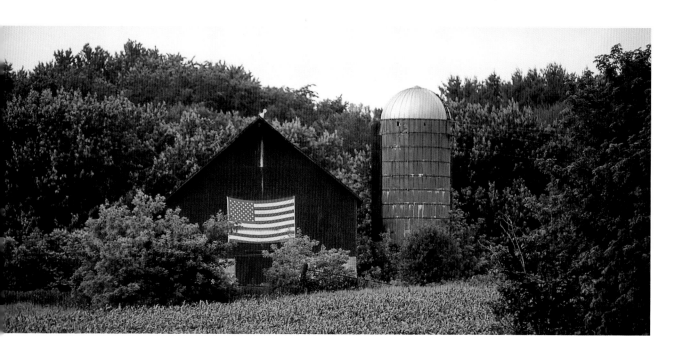

Olmsted County

denly holds up her hands as if to keep him from coming closer; she starts to walk backward. The sheriff hurries forward and catches her hand, so she won't run or stumble. Emmet comes before her and drops to his knees; he holds out his hands, palms up, and the piece of a paper, the telegram, falls to the earth. He clutches her legs as if he's a boy and she holds his head against her belly. They stay that way, holding each other, and the sheriff finally drives away. When they break away, both turn to look toward the barn.

"Ralph," Emmet says, his voice sounding funny. "It's Joseph. He's gone."

Ralph stares. He knows this. Joseph has been gone for nearly three years, first to college, then to the Air Force. He comes home in his uniform, his soldier's cap, then goes away again. He's gone most all the time.

There is a big funeral for Joseph, a hero's funeral. The edges of the cemetery are framed with yellow birch and red oak leaves; in the foreground is a large crowd of neighbors and townspeople and old veterans wearing their own colors sitting in perfectly square rows around the open grave with a silvery casket perched on a frame. Emmet, Clara, Emma, Dorothy, Lyle, and Ralph are dressed up. Even Ralph is wearing a white shirt and tie. The casket is the aluminum color of the silo roof. The casket has not been opened, and so Ralph's grief about Joseph is like rain on the horizon, rain clouds that gather, rain that he can smell, but rain that never falls. Some old soldier plays a horn, there is a rifle volley, and then another soldier gives Clara a folded flag. After that they go to the school cafeteria for lunch.

In the buzz and hum of the lunchroom, Ralph is first in line. There are ham buns, Sloppy Joe hamburger on buns, turkey and chicken on buns; there is jello, pickles, relish, cake, cookies, date bars, pie. He takes a giant plate of food and sits down. When no one is looking he slips a couple of ham buns in his pocket, and several chocolate brownies, too. People come by and speak to him, put their hands on the back of his neck and say how sorry they are that Joseph is gone—and what good buddies he and Joseph were. He grins and nods but in truth he is getting nervous about the time. It's almost three o'clock. Ralph begins to fidget. He has been gone from the farm since midmorning. The cows will be milling around the back door, waiting to get in and eat their grain and be milked. No one will be there to let them in.

They don't milk until seven o'clock that night, and the cows are crabby and their udders are

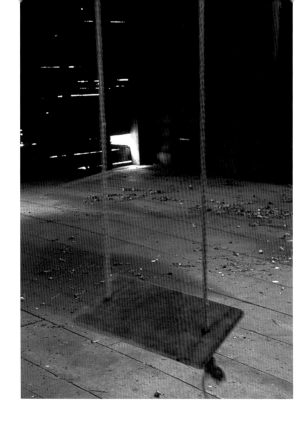

mostly white in the space of a month, and the corn chopper still sits in the field, midrow, where it stopped when the sheriff came.

Neighbors come and help Emmet fill the silo, and for a couple of days there is noise and liveliness and things are like they used to be. But then the November gray sets in, along with the first snow. On Thanksgiving day Ralph is in the dim and chilly hayloft throwing down bales, when he walks past the rope swing. The empty swing. He gives it a push. It comes back to him. He puts his boot in the leg loop and grabs ahold above. He has never tried the swing before, only Joseph. The boy was a good swinger.

Ralph kicks awkwardly, but cannot get going. Cannot get the swing to move. A swing is no good without someone to push. A swing takes two people.

And then it hits him.

He sits silent in the swing until Emmet calls for him. "Ralph? Are you up there? Come in for supper."

He gets up from the swing and goes to the house and into his room where he locks the door.

"Ralph," Clara says, tapping on his door. "Are you okay? Are you not feeling well?"

Emmet milks the next morning because Ralph

swollen tight with milk. The next day things are off-kilter as well, what with cars coming and going, and life continues this way. Everything is different. The food Clara cooks is different; it is not always cooked right. She forgets to put salt or pepper on things, and once made a cake with two cups of salt rather than sugar. Not even the dog would eat it. In the evenings, after all the people stop coming, there is silence but for the sounds of the oil burner—the whisper of flame in its isinglass window. At night there is sobbing in the bedrooms, and downstairs too. Emmet's hair turns

does not leave his room. Ralph stays inside his room all that day. He has food of course, his own cache, and it's dry and hard but still good. He hears voices outside his door, calling to him, first Clara, then one by one the kids after school, but he does not unlock it.

That evening they look up with relief as he comes downstairs.

"Ralph, we're glad you're feeling better. I'll cook you some eggs," Clara says.

"No. I have to go to the barn," he says. His voice has become thick from disuse.

"Why Ralph?" Emmet asks. "Everything is taken care of. The chores are all done."

"I have to check on something," he says.

Emmet and Clara glance at each other.

Ralph trudges across the yard to the barn and disappears inside. Emmet is watching as the highest pair of hayloft windows wink on yellow. "Why is he going to the hayloft?" Emmet says.

"I already threw down ten bales," Lyle says. Lyle is fifteen now, a short and strong boy resembling Emmet more than Clara. He likes machinery—is a better mechanic than Emmet.

"Someone better go check on him," Clara says. "Lyle."

Lyle groans, but is happy to give up on his math homework (he is not the bright, quick student that Joseph was). "He's probably throwing down bales for all next week. You know Ralph."

Emmet watches his son shrug on a jacket. "No, I'll go," he says suddenly.

"What?" Lyle says, further annoyed. "I said I'd go, dammit." He has taken to swearing on occasion right in front of them; it has something to do with Joseph being gone, they understand, and they do not punish him.

"Stay here!" Emmet says. He yanks on his boots and does not stop to zip his jacket. He hurries across the yard, then into the barn and up the ladder to the loft. There is Ralph in the rope swing. Ralph hanging by his neck. ◙

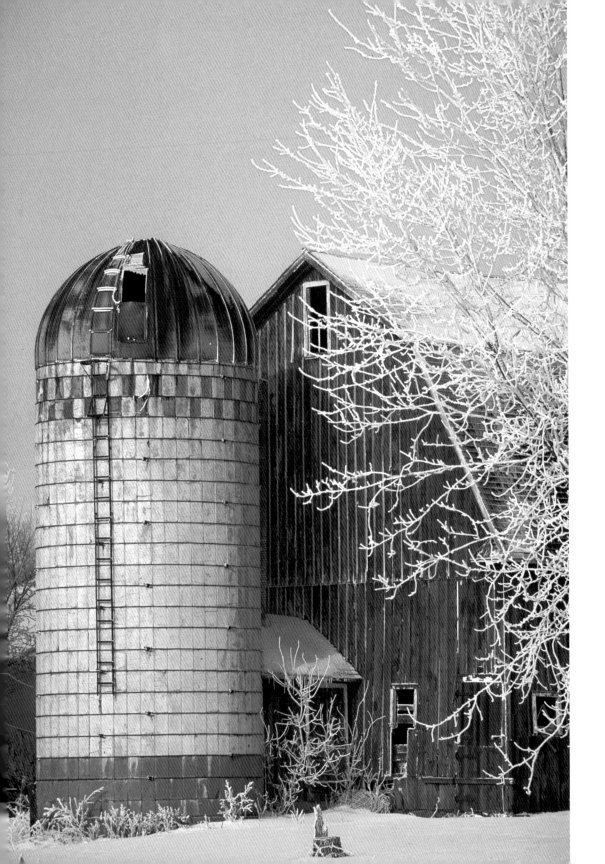

LEFT Sibley County, 1920s

BELOW Murray County, 1940s, horse barn on a small hobby farm outside of Balaton

NEXT PAGES Mower County

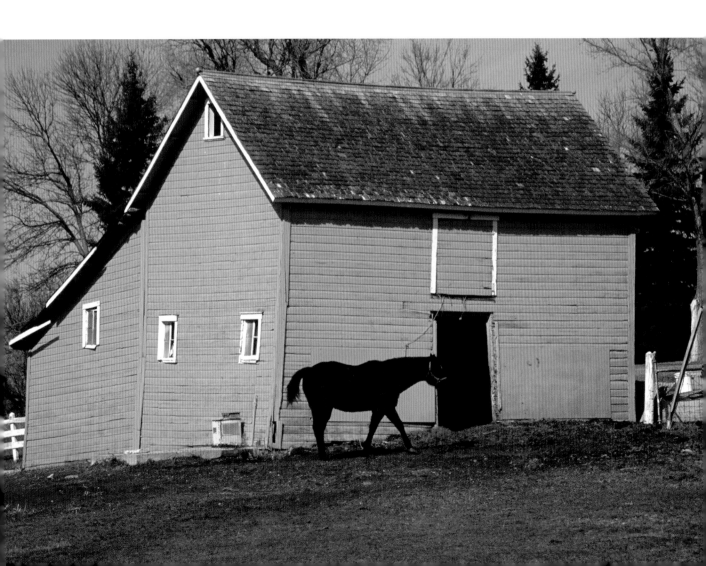

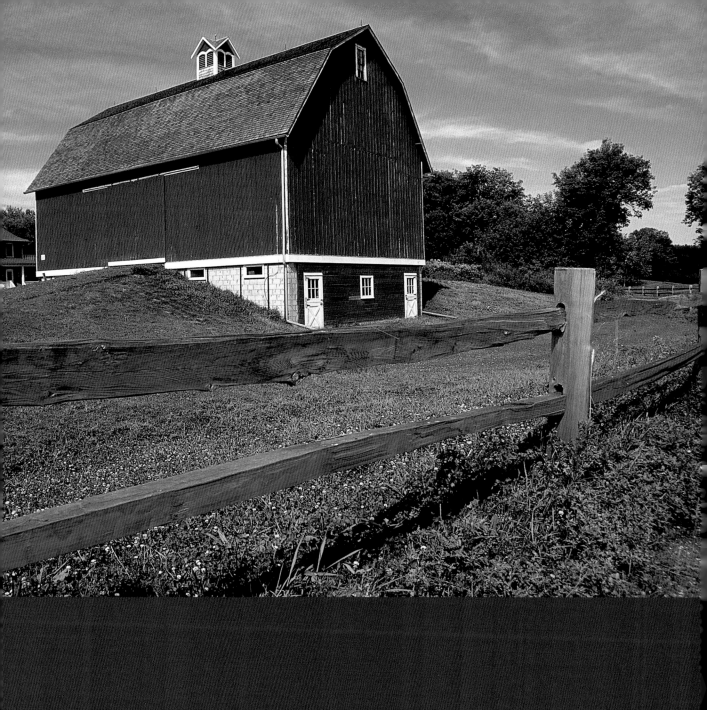
Ramsey County, 1895, the Bruentrup Heritage Farm, home of the Maplewood Area Historical Society

1955 ◙ GOLDEN YEARS

In the summer of 1955, in the shadow of the barn's face,

Ralph stands on a hayrack at ground level and tips square bales

onto the conveyor. He can no longer work in the hayloft (Emmet

hires hay boys for that) because of the injuries to his throat and

voice box. He breathes with a chronic rasp and cannot stand the

dust and heat of the loft. Which makes him mad. The hay boys

up there are not stacking the bales right. They do not crisscross

the bales and keep the rows level. There are no good hay boys

anymore, Ralph believes. ◙ Emmet and Lyle run the tractor and

baler, and Dorothy, now twenty-six and a teacher in town, helps

out by running hay wagons back and forth. She drives the little

orange Allis-Chalmers, and Emmet the big red M Farmall that

pulls the John Deere wire-tie baler. Lyle rides the hayrack and

stacks bales. He does not like haying time; square bales must be

handled several times, which requires lots of hired help. The baler is way better than putting up loose hay, but it still seems inefficient to him. Without Dorothy, they would have to hire yet another man, plus a hay crew means lots of cooking for his mother.

The haying crew comes in for noon dinner. Clara requires that everyone wash up in the summer sink and there be no caps at the table. She is hardly finished with dishes by three o'clock when it's time to bring midafternoon lunch to the crew, a visit which allows her to check on Ralph and the hay boys. If Ralph hears laughter and goofing-off in the loft, he loads the conveyor with bales bumper-to-bumper—like Joseph used to do to him—and soon the hay boys, red-faced and sweaty, appear in the hayloft doorway to swear at Ralph (which he secretly enjoys).

There is much less for Ralph to do now that Lyle has joined the farm full time. College was not for Lyle. He lasted less than a year and spent much of that time carousing, Emmet and Clara believe. But he got the wildness out of his system and managed to meet a nice farm girl and marry her a year later. Now he and his wife Jenny live in the old log house, which Lyle remodeled himself. Lyle is now a partner with Emmet. Twenty-four

cows are not enough for two families, so Lyle works out (like Emmet used to at that age) part-time for other farmers, and Jenny clerks at the courthouse. Her town job provides health insurance, a relief to Clara, and together the young couple saves their money in order to buy a quarter section from Emmet so they will have land of their own. Emmet has seen too many father–son operations go bad because the old man owns everything and the son feels like a hired man.

They make plans to enlarge the barn—but what type of addition? "We don't want another hayloft," Lyle argues. "Haylofts are a thing of the past."

"Where are we going to store enough hay for forty cows?" Emmet counters.

"We build an open-sided bale shed," Lyle says. "We can get used power line poles and a crew to set them. Add prebuilt truss rafters and a metal roof, and we're done. A bale shed is way cheaper than a big old hayloft."

It takes very little figuring to see that Lyle is correct. "Plus it's not like we're ever going back to loose hay," Lyle adds.

So they decide to add sixty feet to the rear of the barn. A low-roofed, modern-looking addition. Lyle believes that rather than have calf pens at

Hennepin County, 1904, rare example of a German forebay barn in Minnesota

the far end, they should extend the gutters all the way down, "Just in case."

"In case what?" Emmet asks.

"In case we go to more than forty cows."

Emmet laughs out loud at that; Lyle's face turns angry. "You'll see, Pop."

Reluctantly Emmet takes out a bank loan— his first ever—to complete the barn addition plus add twenty feet of height to the concrete silo. He stopped short at buying an electric silage unloader. "Ralph needs something to do," he tells Lyle.

The new barn addition had concrete-block wall construction with truss rafters and fiberglass insulation. They had trouble with sealing the joint where the new barn met the old—it leaked badly in the first rainstorm—but gradually Lyle solved

this with more tin flashing and pine tar. Solved it mostly. Every couple of years the seal between old wood and new metal began to leak again.

By 1960 they are milking fifty cows—one of the biggest Grade A dairy operations in the county—and the new barn and silo additions are paid for. Lyle reminded his father of their "we'll see" conversation. Emmet shrugged but smiled. The milk check is bigger than Emmet could ever have imagined—plenty for two families. Lyle and Jenny buy a new mobile home and move it across the road onto their own land. Emmet turns most of the farm management over to Lyle, except for care of the "old barn."

Which is what they naturally call it now. Emmet mentions that the old barn needs painting again.

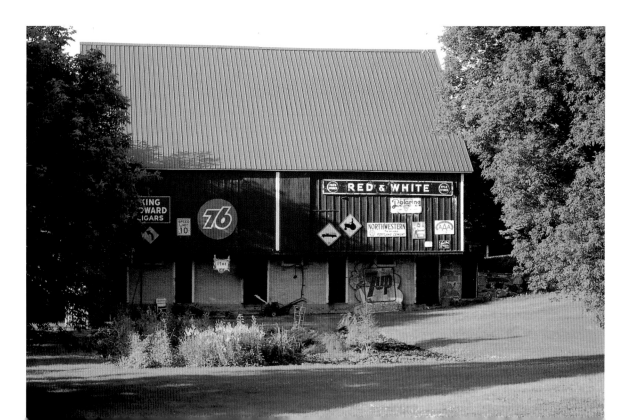

It will be the third time already, but it should be done. The red oxide has faded and peeled in spots; along its fieldstone foundation is a fine red dander from checked and flaking paint above. The barn's roof is still good. The cedar shingles have grown moss on the north side but that only makes them more watertight. But the painting must be done. Plus there's that leak again where new barn meets old.

"We'll get to it in the fall," Lyle says impatiently. "Or next spring for sure." The old barn finally gets painted, by a fly-by-night crew (hired by Lyle) who use an electric sprayer. The wood should have been scraped, wire-brushed, then primed in spots, but Lyle believed the high-pressure sprayer would kill a flock of birds with one stone. The new paint is thinner than the old paint, but soon, from a distance, Emmet's barn looks bright red and new.

The roof is another matter. The previous summer a dozen cedar shingles blew off near the ridgeline and there is a bare spot of roof boards. It has rained several times since then and Emmet has nagged Lyle about patching the roof. Finally Emmet hired one of the Whitcomb grandsons to climb up there and replace the shingles. He made a point of showing the boy how shingles must overlap each other, but the kid is as slow as the rest of his family. Using binoculars, Emmet can see that some of the shingles will not shed water correctly. Inside the loft, there is a faint dark flower of water stain on the roof boards. He tells Lyle, and Lyle says those Whitcomb boys are dull as hoes, and if Emmet had only waited, he would have taken care of it himself.

But Lyle is busy. He has bigger fish to fry. He has been researching electric barn cleaners and pipeline milking systems. "All the big dairy operations have them."

"If we get a pipeline milker and barn cleaner, you can throw away your pails and shovel," he tells Ralph, who nods uncertainly.

But Emmet can see the writing on the wall. Ralph is almost sixty years old and Emmet is sixty-one. Both have carried enough milk in pails and shoveled enough cow dung and silage. In 1966 Emmet takes out his second loan to buy a silage unloader, a pipeline milking system, and an electric, chain-driven gutter cleaner.

The pipeline milking system is the biggest change. No more Surge kettles, no more pails, no more "StepSaver" tanks needing to be cleaned every morning and night. The pipeline is a sealed, sanitary, clear plastic pipe that runs along the old

beam just above the vacuum line and carries the cows' milk directly to the refrigerated bulk tank in the milk house. Dorothy now milks on occasion, especially in summers, and even Emma, who is now a college professor, can handle lightweight milkers. This frees up Lyle to do more row-crop farming on his land. When the "girls" milk, Ralph gets moody and crabby but they know him well enough not to be bothered. Dorothy is his favorite; she often brings fresh cookies to the barn when she milks. He keeps an eye on Emma just like he watched Joseph; she doesn't know cows and the cows know it. Ralph worries that she'll get kicked or switched in the face by their long tails. Ralph makes sure to milk Bessie, Hilda, and Dora, cows who can't be trusted.

Lyle has his own problem of farm management: "square" bales. There is still no good shortcut to handling and rehandling small bales, and it is increasingly difficult to find hay boys of any kind because there are fewer and fewer farms. In 1972 he hires a farmer to put up some of their alfalfa into big round bales, a new development in haying technology. "It's a one-man operation," Lyle says.

The big bales, at nearly a thousand pounds, are difficult and dangerous to move, plus nearly impossible to use inside a barn with dairy cows.

It takes two summers, but Lyle finally gives up on round bales: he decides to get away from dry hay altogether.

In 1974 a salesman from the Harvestore Silo Company arrives at the farm. He's a younger fellow named Ken and has brochures for Emmet showing the trademark shiny blue silos. With Lyle looking on, he pitches the idea of haylage: hay chopped mostly green, then put into an airtight silo. "With dry hay, you lose half your alfalfa leaves. They get knocked off raking and baling, and the leaves are where the protein is, right?"

Emmet, who does not like salesmen, has to nod yes to that.

"But with haylage," Ken continues, "you're cutting it green so the leaves stay on. You end up with haylage of forty, fifty percent moisture that has up to 20 percent protein. You'll never get that kind of protein level with dry hay."

"If it's that wet it will spoil," Emmet says.

Ken leans forward as if Emmet has fallen into a trap. "That's where our silos are different," he says. "Ours are airtight. It's oxygen that creates spoilage. And "

"No oxygen, no spoilage," Lyle finishes.

Emmet glances from Lyle to the salesman; it's clear they have met before and talked things over.

The idea of a silo without oxygen is bothersome–silos are dangerous enough already. And the cost is staggering: in the neighborhood of $30,000 for a silo twenty feet in diameter by seventy feet tall. "I don't know," Emmet says skeptically, "it's a lot to think about." He checks his watch, and excuses himself. The salesman and Lyle walk away, toward the concrete silo. Once Emmet hears them laugh.

Later, he and Lyle talk. "Just think, Pops, no more baling," Lyle says.

"I don't mind baling," Emmet says. "I kind of like the smell of hay." The red clover, alfalfa, Timothy, Bromes grass is something he would miss. And the old hayloft. He can't imagine it empty.

Lyle keeps talking, endlessly, about haylage, field choppers, and blue silos. "Things are changing, Pops. We can't stay the same," he says. He pesters Emmet into taking an overnight trip down to southern Minnesota to visit a farm with Harvestores. "One man does everything," Lyle says. "No

labor costs, no hired help to deal with. Think of how much easier it would be on Mom."

They arrive in Wright County late in the afternoon and find their way to the farm by milking time. All the barns are the new kind, shiny metal, long and low. Two Harvestores rise up like skyscrapers. There is an old barn, but it is very small and its roof is bowed and mostly bare of shingles. Emmet guesses it was built at the turn of the century or even before. The old barn will fall down soon, in another year at most.

In the new barn, the man's wife is milking; there is a stroller parked in the alleyway behind the cows. "He's chopping hay," the wife says. She is a handsome, strong woman who wears a red bandana and her cheeks are flushed pink from exertion. She doesn't stop milking even to talk: spray udder, wipe teats, attach milker; turn to other milker, which is starting to gurgle and suck air on the adjoining cow. Emmet counts forty on each side. The barn is so long that the cows at the far end look the size of calves.

"Thanks," Lyle says cheerfully. She briefly lifts her chin in reply, then turns to the stroller where the baby has started to fuss.

Lyle and Emmet walk into the field where the farmer, Dan Roberts, is driving a new John Deere with enclosed cab and tinted windows. Hooked behind is a forage chopper whining at high rpm; it is cutting green hay, shredding it, and blowing it through a curved chute into a power wagon behind. The noise is deafening; Emmet steps slightly behind Lyle. The farmer slows the tractor and chopper to a stop, but does not turn off the engine.

He swings open the door and drops to the ground. Lyle introduces himself and Emmet.

"Yeah, Ken said you might come by," Dan says. He and Lyle talk about Ken as if he were their friend.

"So tell us about haylage," Lyle says.

"Well, it's not all that different than putting up silage," Dan begins. "But when the silo is full, the oxygen is blown out and the top is sealed," Dan says. He speaks loudly because he has not shut off his tractor and the attached forage chopper hums at steady pitch. "Also, the blue silos are unloaded from an auger in the bottom."

Emmet squints but says nothing. How do you repair a silage unloader that's underneath a hundred tons of silage? Haylage, he means to say. It's an odd word, one that doesn't work right on his tongue.

"If it breaks down, I just call Harvestore," Dan says. He and Lyle grin at each other.

"Any problems so far?" Lyle asks, nodding toward the giant blue towers.

Dan hesitates ever so briefly. "Once or twice I had trouble sealing the top, but Harvestore will send a service guy out."

"And the cows like it?" Lyle asks.

"They love it," Dan says. "Though a guy can't just switch dry hay to haylage in one day. You have to gradually. But now they eat it like candy. I know one thing—I'd sure never go back to baling."

On the walk back to the farmstead, Lyle stares up at the blue silos like they are church steeples. Emmet looks around at the other parts of the farm—the outbuildings, the pens, the machinery. It is a farm that looks good from the road, but the fences are the quick and cheap electric kind; wooden trough feeders in the cow lot are battered and cobbled together. There were hogs here at one time: pigweed, or Amaranthus, grows thick and gray-green behind the older buildings. A grain drill seeder is parked uncovered, a thick green broom of germinated oats grown up underneath. Little white plastic injector tubes for treating dairy mastitis litter the cow lot. A dead calf has been dragged out behind the old barn, where it has been eaten on by something. Emmet sees that Lyle does not notice the dead calf.

On the drive home, Lyle talks a mile a minute. He is a goner for haylage. A convert to the Church of Harvestore.

"So what do you think, Pops?" he says finally.

"I don't know," Emmet says slowly. "I'd have to think long and hard."

"You'll see," Lyle says cheerfully. They approach the edge of a small town where there's a Dairy Queen.

"Let's stop," Lyle says. He sounds like a little boy. "I'll buy you a burger and a malt."

They sit at an outside table and eat. Emmet realizes he has hardly ever gone anywhere with Lyle. On the rare vacation, it's always one or the other who takes a fishing trip or drive out to the Black Hills. They never go together.

"What?" Lyle says.

"It's nice to get away." He thinks of Joseph, then feels guilty about that, puts it out of his mind.

"We should do this more often," Lyle says. They take their time. They are in no hurry to leave.

In late winter of 1975, a quiet time of the year when farmers read up on things and order seed and supplies, Emmet and Lyle drive to the Farmer's State Bank in town. Around the boardroom table, a long wooden table with uncomfortably soft armchairs (the "skinning room" as Emmet calls it), they

meet with the banker, a man from Farmer's Home Administration (FMHA) loan agency, and Ken from Harvestore. The papers are all in order. The loan is for $75,000. It includes a 20 x 70 foot Harvestore, a New Holland forage chopper, two forage-box wagons, an automatic conveyor feeding system, and another forty feet of addition onto the new barn.

"No good one part without the others," Lyle and Ken say.

The Emmet Anderson & Family farm will now milk seventy cows with the help of Dorothy's son, Travis, who wants to move back to the farm from the Twin Cities. Lyle and Emmet have gone over and over the numbers. The debt load. The milk production. If the 70 cows produce an average of 20,000 pounds of milk per year, and milk is $12 per hundredweight, then each cow brings in $2,400 per year. This times 70 equals $168,000 in milk check alone. That's not including bull calves and steers (which they sell), plus extra income from Lyle's row crops. Payoff will be ten years, maximum.

"You'll have the best dairy in the county," Ken says.

The FMHA man smiles and agrees.

The banker says, "With a family like yours, Emmet, I have no worries."

The FMHA man and Ken from Harvestore sign first, then Lyle, who hands the pen to Emmet. Lyle is smiling and excited. Emmet knows how badly Lyle wants this; he sees the eagerness, the excitement in his face. How can he say no to his only son? How can he disappoint him so? Emmet takes the ink pen but he thinks of that farm they visited in southern Minnesota: the frazzled young wife in the barn; the frightening loudness of the high-rpm haylage chopper; the dead, half-eaten calf in the pigweed. He has thought of the dead calf more than once—for some reason that calf will not go out of his head. He lays down the pen.

"I'm sorry," he says to Lyle. ◙

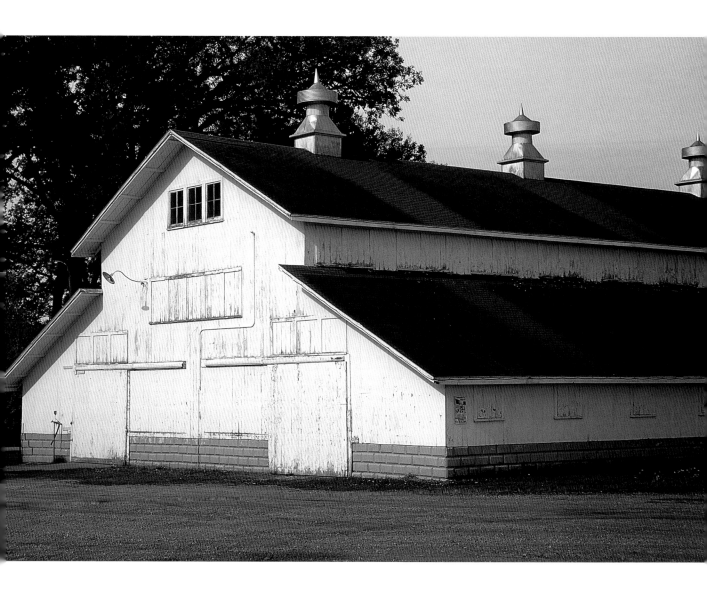

ABOVE Faribault County, 1940s, county fairgrounds poultry barn

RIGHT Faribault County, 1927, Gothic barn with glass block windows

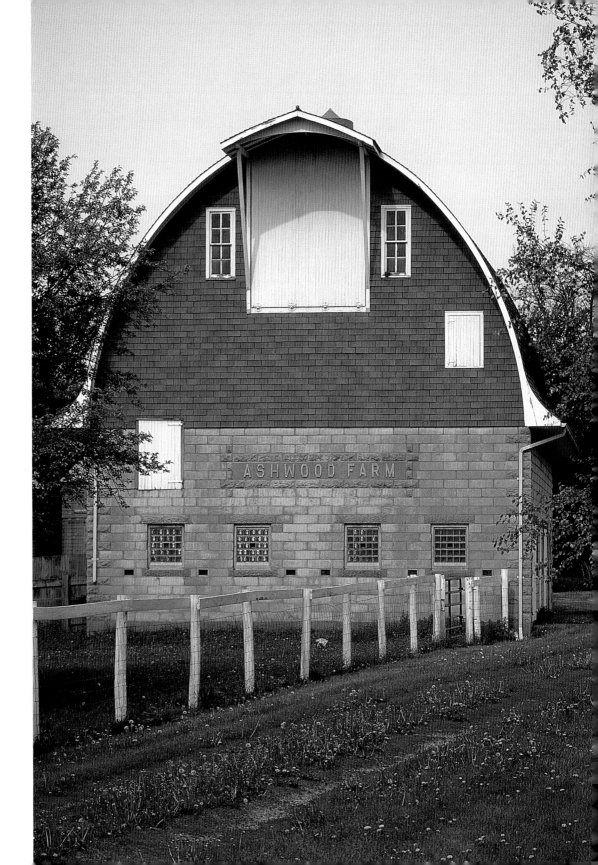

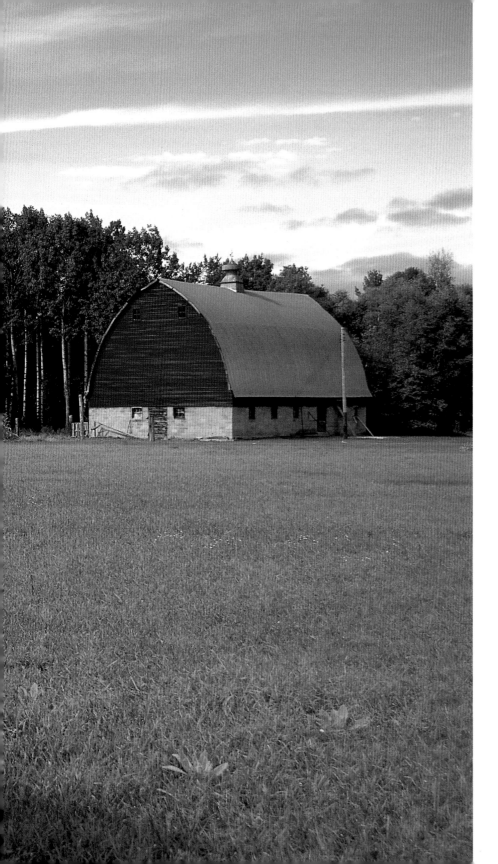

PREVIOUS PAGES Crow Wing County, 1930s, Gothic barn

BELOW Goodhue County, 1890s. The old barn continues to be used today on the modern farm.

RIGHT Winona County, 1926

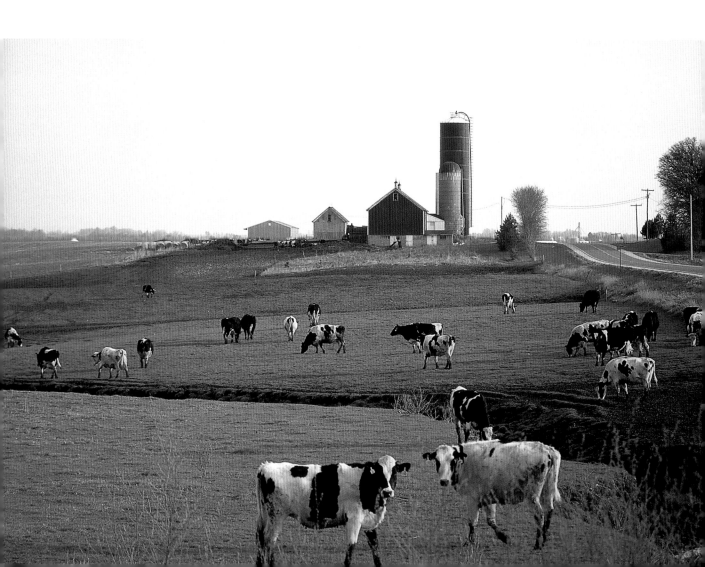

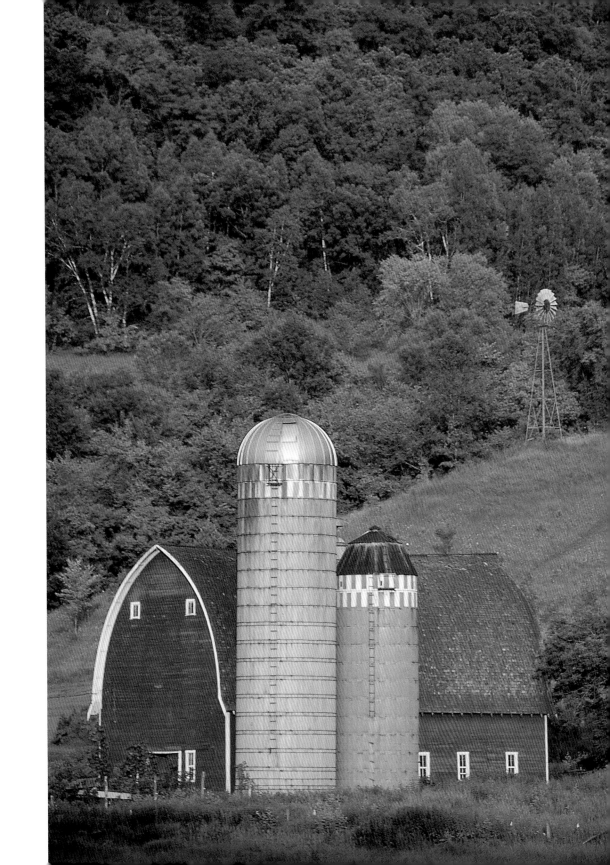

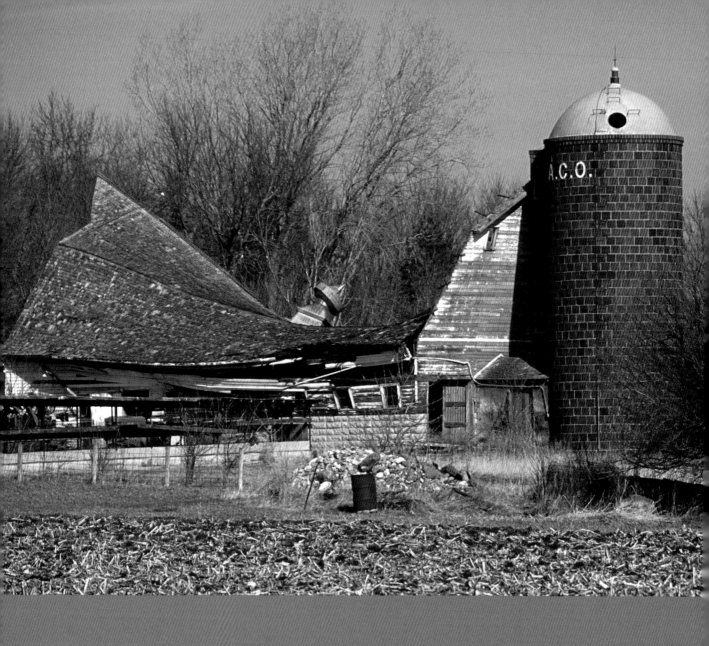

Lincoln County. The ACO silo outlives the old barn.

1980–2000 ▫ FULL CIRCLE

It takes Lyle several years to forgive Emmet. The first

year after the bank meeting was particularly tough on the whole

family. Lyle quit the dairy cows. "I've had enough pulling teats,"

Lyle announced. He stopped lending a hand with anything extra—

certainly barn maintenance—and even hired some town kids to

take his place during haying season. That first year he hardly

spoke to his father and visited the house only twice: on Christmas

and Emmet's seventy-fifth birthday. The grandkids visited less

often as well, and Lyle's wife Jenny was cool to Clara, who in turn

was hard on Emmet. It was not that she necessarily wanted the

blue silo and larger dairy; rather, it was the way it happened.

"After all," she said, "Lyle had a dream just like you had once."

▫ Emmet had no argument with Clara. It was his own fault, not

nipping things in the bud. But in the back of his mind he missed

113

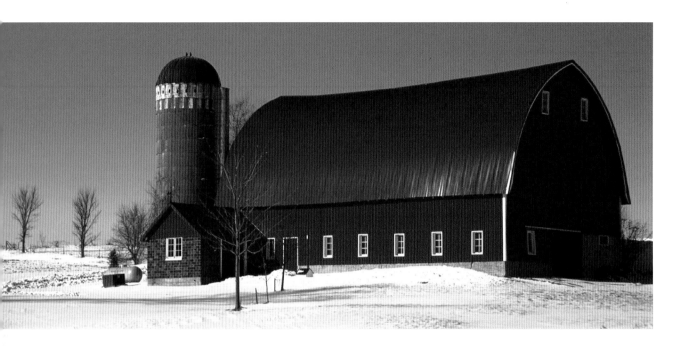

how he and Lyle had spent so many evenings together after supper, Lyle endlessly figuring, calculating, looking at brochures of silos and forage equipment; afterward they would play one game of checkers or whist before Lyle went across the road and home to his own family.

But Emmet was right not to take on a big debt. In 1973, the Arabs embargoed oil, and prices—especially for fuel, fertilizer, and farm chemicals—went through the roof. Even a bale of twine went from around ten dollars to close to twenty-five dollars. Most things, farm implements in particular, went up in price and stayed up. A new tractor now cost more than a house, and interest rates on loans grew to double digits. Compounding matters was the worldwide recession that began in 1981, which depressed global demand as well as the prices for American farm products. Milk prices fell to below $10 per hundredweight, and farmers with the most debt load went under.

ABOVE Carver County, 1940s

RIGHT Carver County, 1960s, Western-style horse barn

Emmet sold the dairy herd in 1976, in the main because he and Ralph couldn't do it alone anymore. He bought a few head of Hereford beef cattle, enough to keep Ralph and him busy, and let Lyle grow corn and beans on most of the home place.

One Saturday in the summer of 1983, Lyle called the house and asked Emmet to go with him to a dispersal auction. A "big farmer" they knew in the south end of the county was selling everything. Lyle—who had his own money, he was quick to say—wanted to look at the man's corn planter, a nearly new, eight-row John Deere seeder.

"That will be so nice, a little outing for you," Clara said to Emmet.

When Lyle tooted his truck's horn Emmet was waiting by the door, and they drove off mostly in silence. It was a fine sunny day in July; the auction was marked with bright red, flapping flags at the crossroads. Lines of cars stretched along the ditches leading up to the farm. The auctioneer stood atop a hayrack crying the small stuff—shop tools, shovels and forks, an old hand-crank corn sheller—and behind were the rows of implements, a spread of John Deere green. Behind them was a long, new barn—and a blue Harvestore silo. A crew of men Emmet did not recognize (their truck had

Illinois plates) was dismantling the silo with air guns and hydraulic wrenches. They worked fast and efficiently.

"Repo," Lyle said. "They'll sell it to somebody else."

Emmet was silent.

They watched the Illinois crew work. The silo came apart from the bottom up; with the entire structure on giant jacks, the wide blue hoops one by one were slid out from underneath each other.

Finally Lyle said, "Let's go look at that corn planter."

The price was a steal, and Lyle bought it. Emmet bought the old corn sheller. "I still don't

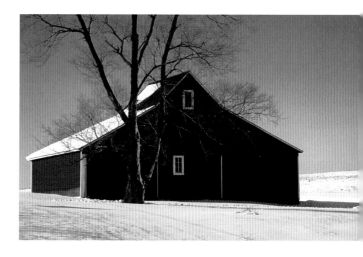

know what you're gonna do with that thing," Lyle said as they left the auction.

"Me neither," Emmet replied.

Lyle laughed briefly at this and Emmet smiled.

On the way home Lyle drove into town where they stopped at the John Deere dealership to buy some new disks for the planter. While Lyle talked to the parts man, Emmet walked over to a shiny new dual-tandem tractor sitting on the showroom floor. Its wheels were two feet taller than Emmet; the windows were tinted so darkly, he couldn't see inside the cab.

Heading out of town, Lyle braked suddenly and pulled into the Dairy Queen. "I'll buy you a malted, Pops," he said.

"You bought last time," Emmet said, fishing out his wallet.

They ate their ice cream in comfortable silence and watched the traffic. The summer tourists in motor homes, the fishermen pulling boats.

"I guess things have a way of working out." Lyle said at length.

Emmet was silent. He supposed Lyle was talking about the blue silo that he never had, so he only nodded.

They were silent again for awhile.

"I was thinking we should reroof the old barn one of these days," Lyle said, turning to his father. "Before it gets any worse."

"That would be good," Emmet replied. "It's time."

But then Clara had her heart attack. A bad one, and afterwards she couldn't do much of anything around the house. Emmet, for the first time in his life, tried cooking—that is, when Lyle's wife couldn't bring over supper. Ralph was nervous about this arrangement and took to standing at the living room window so he could look across the road to see if Jenny was coming with covered dishes.

The barn roof project is forgotten as the family comes together around Clara, who does not survive a second heart attack that next spring.

After Clara's death, Emmet sells his beef cows, keeping only a few steers for Ralph to feed. Life is like he is underwater. His arthritis is worse and he takes to walking with a cane. Ralph is bent and stooped as well; Emmet understands that the years of work with fork and shovel and heavy milk pails have caught up with them both.

In the end, it is not the roof that brings down the barn: it is the leaking joint where the new barn meets old. Emmet has not looked closely at the rear of the barn for months—even years, possibly—and water has slowly worked its way down the

boards and beams, rotting them from the inside.

One night in 1993 Emmet hears a cracking sound, like lake ice freezing in winter. But this is summer. He gets up to look out his bedroom window. The moon is shining strangely bright on the face of the barn, which has tipped backward several degrees. It's as though the barn is trying to look up at the stars.

In the morning, first thing, he and Lyle and Ralph inspect the old barn. The back wall has buckled, tilting the whole barn to the west and breaking its spine as well. The ridgeline beam is cracked, but still holds. The old barn has separated itself entirely from the new addition.

"I'll call the insurance man," Lyle says.

"Why?" Emmet says. "It's not like a storm hit it."

"Still, maybe there's something we can do," Lyle says.

"I don't think so," Emmet says. They stare up in silence at the odd angles, the bowed back, the tilted cupola.

"I know these guys who do barn straightening," Lyle offers.

"Too late," Ralph wheezes. "She's a goner."

Out of habit, Ralph still gets up at five A.M., but then only a couple of weeks later, he does not. Emmet wakes at six thirty and realizes that Ralph has not gone out for chores. He lies there. The house is silent—a belled, full-but-vacant silence of an empty hayloft, an unfilled silo—and he knows Ralph is gone. Emmet doesn't go up there, to Ralph's room; he calls Lyle.

Ralph's funeral draws way more people than Emmet expects. The funeral home is mostly full, though the average age of most folks has to be older than seventy. Emmet's whole family is there, all the grandkids, too, and their faces are shiny with tears. Emma, the college professor, gives the eulogy. She speaks to the changes in farm life and small towns—how Ralph was a symbol

of continuity in a sea of change. She calls Ralph "the last hired man."

Then it is Emmet's turn to say a few words. At the podium he looks out and sees faces he has not seen in many years. A few old farmers from the feed mill days. Some of the Whitcomb family. A couple of the Deukmans (Hans is long gone). Ralph's sister Sonya and her two grown children; though she has to be seventy-five, Sonya has dyed brown hair in a stylish permanent wave and modern glasses on a chain. Her children look successful.

Emmet clears his throat but has no words. Emma used them all; Ralph was the last hired man. What more is there to say?

"Ralph," he begins. Then goes blank. "Ralph was a man who could get up in the morning. And who knew how to eat."

There is laughter at the last part, and Emmet sits down. After the funeral there is a very fine lunch—all you can eat.

Emmet stays on alone in the big house. His health is still good, and besides, why would he want to move to town? Lyle and Jenny are just across the road. Time passes dream-like, the days like a river, seasons suddenly appear as a different color in the windows. And then comes the spring storm in 1995.

The winds are straight-line from the west, gathering speed until the night howls. Emmet barely hears the barn go down: the sound is a deep "thud"—like an old wirebound hay bale dropped from the loft onto the concrete floor. He gets up to look but the rain is whipping like torn sheets and he cannot see across the yard.

In the morning he and Lyle inspect the wreckage, the mess. "Sorry, Pops," Lyle says. He puts his hand on his father's shoulder.

"Happens to all of us one day," Emmet says, and turns back to the house. The old barn is oddly unimportant to him because he spends much of his time in the past. The past when everything was new.

And then, suddenly, it is that warm summer night in 1999, when the moon is shining more brightly than he can ever remember. He is looking out on the yard and holding his chest. He is talking to Bill Johnson, or Hans Deukman, or those Indian men who made the cedar shingles, or those lazy Whitcomb boys. Or maybe it is Clara, thanking her for bringing lunch to the field—or Joseph, warning the boy against climbing so high. He is talking quite clearly to someone when Lyle arrives in his bedroom doorway.

"Pops, you all right?"

Lyle, his gray-haired son who stays here most nights now. Lyle who changes Emmet's bedding and his underwear when he soils them, which is every day. Lyle, a good son.

"Look, Lyle," he says, pointing through the window toward the risen barn. "Look!"

The following summer, a year to the day after Emmet's funeral, his family holds a picnic and barn recycling party. It is the grandchildren's idea: invite the neighbors and local people to eat, socialize, and take what they want from the old, fallen barn. Beams. Posts. Weathered siding. Cedar shingles. Door hinges and latches. They are amazed at the turnout—cars and pickups and small trailers fill the yard—and at the variety of uses planned for the old barn wood: bookshelves, rustic wall paneling, deer stands, cabinets, entertainment centers. Lyle gives the main beams to a capable young couple who raise and sell free-range chickens, and who are building a small house from all "found" material. He saves several straight, gray boards for himself. That winter he makes a frame for Emmet's original drawings of the old barn. At the bottom, in careful handwriting, are Emmet's own words: "A barn will build a house." ◙

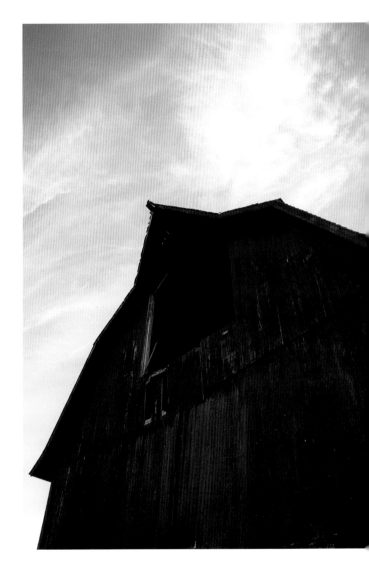

Waseca County, 1910

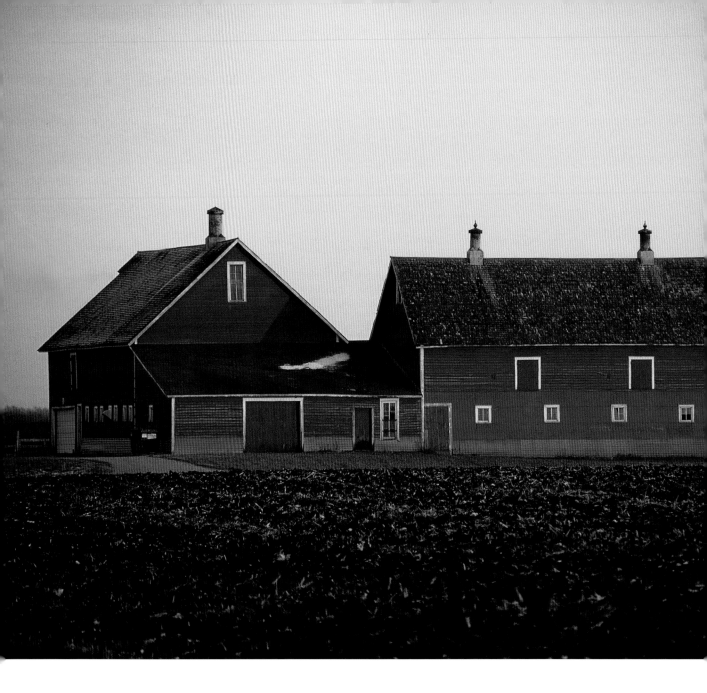

ABOVE Redwood County, 1890s

RIGHT Le Sueur County, 1950s

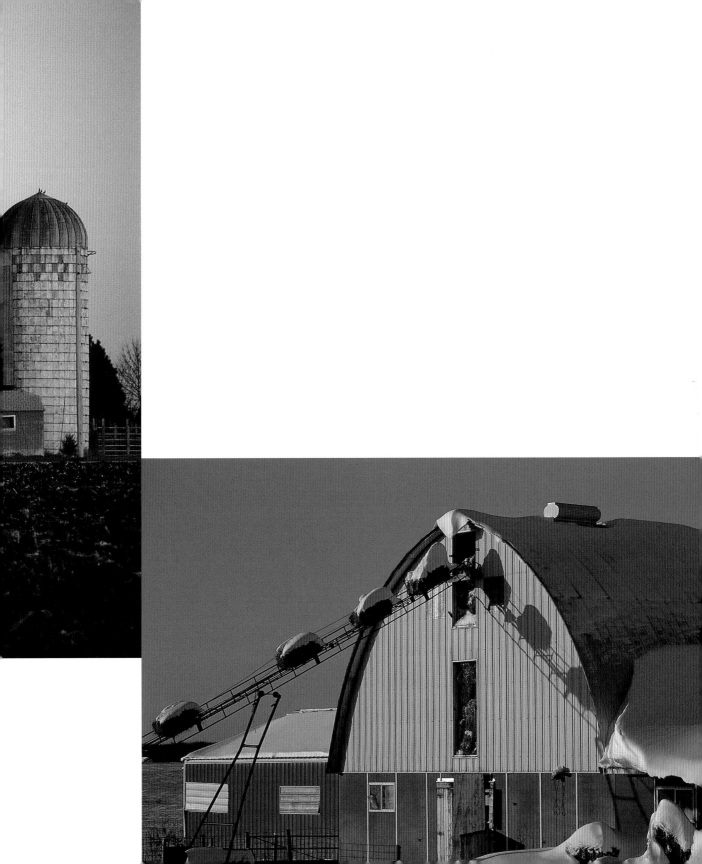

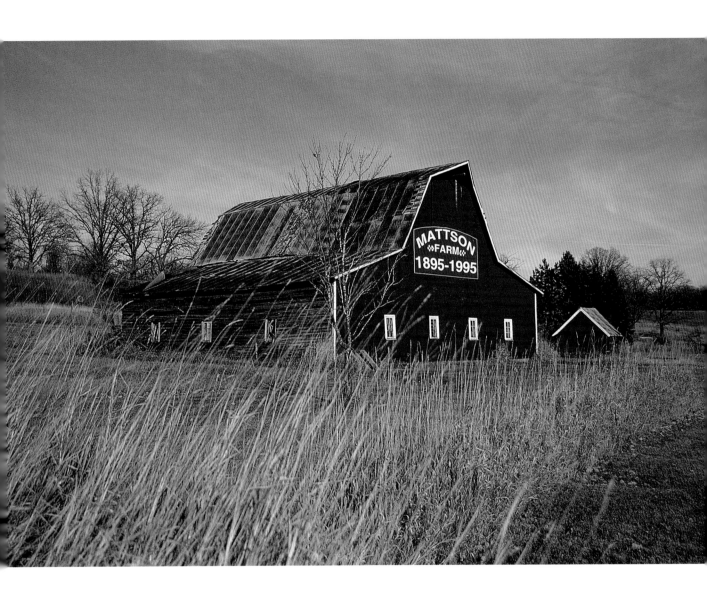

LEFT Waseca County, 1885

ABOVE Kanabec County, 1895, a Western-style hay barn that's over a century old

NEXT PAGES Goodhue County, 1920s, one of four "poetry barns" found outside of Red Wing

▣ AFTERWORD

In the end, what is the future of our old barns? To the farm families who own them, a wooden barn is like an antique car that no longer runs. It takes up valuable space, needs costly maintenance, and is dangerous for the grandkids to play in. To repair or not to repair: that is often the agonizing question for the family to whom their barn was central to life and livelihood. A kind of paralysis can set in. Time passes. No decision becomes the decision. The old barn begins to lean and creak in the wind.

If our old barns are fading away, their place in our language, at least, is fairly secure. The word "barn" has Anglo-Saxon roots, a combination of *"bere"* (barley) and *"aern"* (place), or a place to store barley. An early reference to "barn" shows up in the Saint James version of the Bible in Luke 12:24. Nowadays barn metaphors fall easily from the tongues of urbanites five generations removed from the smell of cows. A "barn burner" (originally a rural joke about a farmer who burned down his barn to kill the rats) is common sportscaster's parlance for a good game. "As big as barn" and "can't hit the broad side of a barn" are well-worn phrases. "Born in the barn" (as in "where are your manners?") is heard less often these days likely because only 3 percent of America's population now grows up on a working farm—as opposed to nearly 70 percent in 1900. At a more literary level, the barn endures in the work of Robert Frost, William Faulkner, Carl Sandburg, and other American writers. Several old barns in Red Wing, Minnesota,

have poetry written right on them. These "poetry barns" are the work of a writer in the 1970s who convinced a few farmers to lend their barn sides to his verse. He requested that his poetry, like the old barns, be allowed to fade away. Written in letters three feet high, the verse is quite good but barely readable these days. It is worth a trip to Red Wing to find and read the poetry barns.

Beyond language and literature, barns live on in the work of other artists. In early American history barns were so common as not to warrant a second look; however by the 1830s, as America's industrial revolution rapidly outstripped agriculture, barns gradually became objects of nostalgia, symbols of "better" times when people lived closer to God and to the land. Currier and Ives, the New York lithographers, made a fortune with their company's engravings and calendar images of barns and farm life. This sentimental rendering continues through painters such as Norman Rockwell, Terry Redlin, and Thomas Kinkade.

But this book seeks to re-view our old barns. To see them again in a new, unsentimental light. Our goal, by dovetailing photographs and story, is simple: the next time you pass an old barn, we hope your imagination will take hold.

One of the joys of working on this book was talking to people about barns and hearing their stories—and in the Midwest, a surprising number of people still have them. Clayton Knoshaug, a colleague at Bemidji State University, told me how his family's great barn burned to its foundations;

it was the biggest dairy barn in Washington State but a small shard of red-hot baling wire falling on dry hay brought it down—and changed everything for his family. I heard stories of barn dances; of roller skating and basketball practice on smooth, haymow floors; of making out in haylofts; of city kids taking field trips to farms and being frightened of barns cats, barn owls, and strange noises in the loft.

Sociologist Charles O'Conner and historians Tom Murphy and Elizabeth Dunn all had different and useful ideas on barns past and present. And there are several authors to whose work on barns and farming I am indebted: J. Vlach's *Barns,*

D. Plowden's *American Barns,* and notably, Steven Hoffbeck's *The Haymakers,* a moving and meticulous history of five midwestern farm families. Mr. Hoffbeck's book was an invaluable reference as I drew upon my own farm background that was eerily similar, at times, to his. Thanks, too, to Dr. Tom Woods for his proofreading. And of course, to my editor at the Minnesota Historical Society, Pamela McClanahan, many thanks for believing that fiction can sometimes tell the whole story—that truth is not always limited to the facts.

WILL WEAVER

◙ PHOTOGRAPHER'S NOTE

The sound of silence is everywhere as I enter the old barn, camera and tripod in hand. Although the barn is abandoned, with a little imagination I can hear the clatter of cow hooves on the concrete floor and smell the fresh alfalfa wafting from the haymow. An old coat hangs on a rusty nail, a pitch fork leans against a horse-stall door, and a kitchen-sized radio still tuned to wcco is perched next to the cow stanchions. Yes, these are all scenes of barns, but they are more than that. They are scenes of people. Every barn has a story and that story is about hard work, pride, success, failure, and some-times tragedy. I have tried to capture, through photography, a small part of that story.

Throughout this project I have often been asked what I want to pass along to people about barns. Of course, as a photographer, I want the readers of *Barns of Minnesota* to enjoy the pictures, but I also want them to catch a glimpse of a by-gone era, an agricultural era that is quickly being forgotten. As the old proverb goes: "The best way to keep a trail alive is to walk on it. Every time you walk on it, you create it again." My hope is that this book will guide people along that trail and, through stories, memories, and photographs, keep barns alive.

I want to thank the staff at the Minnesota Historical Society Press and Will Weaver for hav-ing the confidence in my photography vision for this project. I also want to thank the many farm-ers, barn owners, and kind neighbors for allowing me and my camera onto their fields and into their barns. Lastly, I want to recognize my wife, Krin, and children, Emily and Matthew, for understand-ing my many days and some nights on the road capturing barn images.

DOUG OHMAN
New Hope, Minnesota

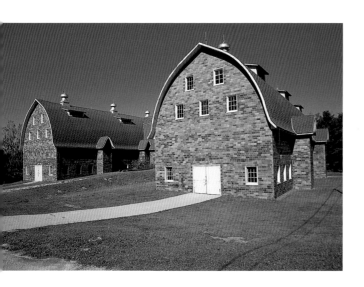

Olmsted County, 1920s, twin dairy barns at the St. Mary's farmstead outside of Rochester